Gauguin

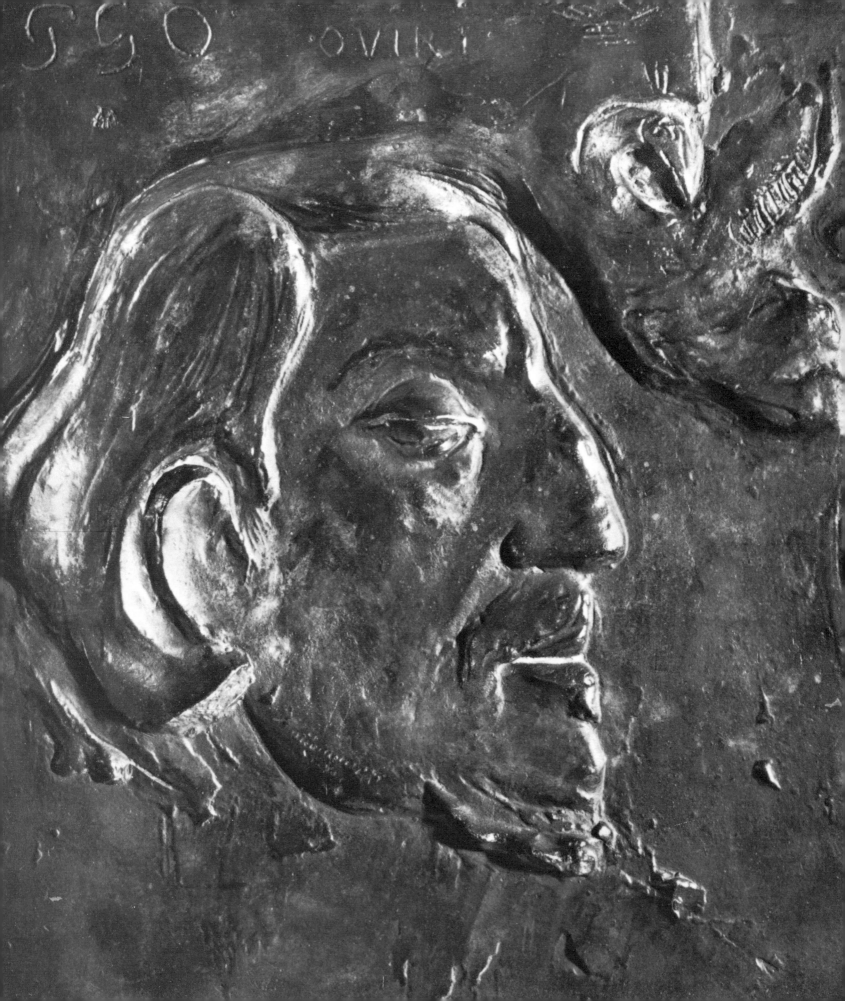

Ronald Alley

Gauguin

The Colour Library of Art

Hamlyn

London · New York · Sydney · Toronto

Acknowledgments

The works in this volume are reproduced by kind permission of the following collections, galleries and museums to which they belong: Art Institute of Chicago (Figure 7); Art Institute of Chicago: Helen Birch Bartlett Memorial Collection (Plate 32); Art Institute of Chicago: Lewis L. Coburn Memorial Collection (Plate 13); Art Institute of Chicago: Mr and Mrs Martin A. Ryerson Collection (Plate 36); Art Institute of Chicago: Joseph Winterbotham Collection (Plate 22); Albright-Knox Art Gallery, Buffalo, New York (Plate 16); The Hon. Michael Astor, London (Plate 8); Ny Carlsberg Glyptotek, Copenhagen (Plates 3, 4, 7, 24); Walter P. Chrysler Jr Collection, New York (Plate 23); Cleveland Museum of Art: Gift of Hanna Fund and Leonard C. Hanna Jr (Plate 48); Courtauld Institute Galleries, London (Plates 38, 39, Figures 3, 8, 10); Nathan Cummings Collection, Chicago (Plate 45); Det Danske Kunstindustrimuseum, Copenhagen (Figures 4, 5); Syndics of the Fitzwilliam Museum, Cambridge (Plate 1); Folkwang Museum, Essen (Plates 46, 47); Mrs Terence Kennedy, East Grinstead (Plate 19); Dr Jacques Koerfer, Bern (Plate 5); Kunsthalle, Hamburg (Plate 10); Kunstmuseum, Basel (Plates 27, 30); Minneapolis Institute of Arts, Minnesota: William Hood Dunwoody Fund (Plate 26); Minneapolis Institute of Arts, Minnesota: Julius C. Eliel Memorial Fund (Plate 29); Collection Madame Huc de Monfried (Figure 6); Musée des Beaux-Arts, Brussels (Plate 17); Musée des Beaux-Arts, Lyon (Plate 35); Musée du Louvre, Paris (Plates 2, 6, 14, 15, 25, 33, 42, Figure 11); Museu de Arte, Sao Paulo (Plate 37); Museum of Fine Arts, Boston: Arthur Tracy Cabot Fund (Figure 9); Museum of Fine Arts, Boston: Arthur Gordon Tompkins Residuary Fund (Plate 40); Museum of Modern Art, New York: Lillie P. Bliss Collection (Plate 31); National Gallery of Art, Washington D.C.: Chester Dale Collection (Plate 18); National Gallery, Prague (Plate 20); National Gallery of Scotland, Edinburgh (Plates 9, 12, 44); Private Collections, Paris (Plates 11, 43, Figure 9); Pushkin Museum, Moscow (Plate 34); Trustees of the Tate Gallery, London (Plates 21, 42); A.S. Teltsch Collection (Figure 1); Mr and Mrs John Hay Whitney Collection, New York (Plate 28). The following photographs were supplied by Kurt Blum, Bern (Plate 5); Brompton Studios, London (Plates 21, 42); George Cserna, New York (Plate 45); Greenberg, McGranahan and May Inc., Buffalo (Plate 16); Michael Holford, London (Plates 8, 39); Raymond Laniepce, Paris (Plates 11, 43); Horst Merkel, Sao Paulo (Plate 37); Eric Pollitzer, New York (Plate 28); Tom Scott, Edinburgh (Plates 9, 44); Tom Scott, Edinburgh: The Observer, London (Plate 12); Stearn's, Cambridge (Plate 1); Giraudon, Paris (Plate 34).

Frontispiece: *Self-portrait. c.* 1893. Bronze bas-relief. 13½ × 14 in. (34.3 × 35.6 cm.). Art Institute, Chicago.

Published by
THE HAMLYN PUBLISHING GROUP LIMITED
London · New York · Sydney · Toronto
Hamlyn House, Feltham, Middlesex, England

© copyright Paul Hamlyn Limited 1961
All plates © copyright S.P.A.D.E.M., Paris 1968
Revised edition 1968
Reprinted 1971

ISBN 0 600 03759 2

Printed in Italy by Officine Grafiche Arnoldo Mondadori, Verona

Contents

Introduction Page 6
Biographical Outline 22
Selected Reading List 29
Notes on the Plates 30

BLACK AND WHITE ILLUSTRATIONS

 1 Self-portrait, bronze relief (detail) Frontispiece
 2 Carved Panels from Hivaoa 6-9
 3 Marble bust of Mette 11
 4 Stoneware Jug 12
 5 Self-portrait Jug 13
 6 Oviri 13
 7 Woodcut: Manao Tupapau 14
 8 Woodcut: Te Po 17
 9 Wood relief: Soyez amoureuses et vous serez heureuses 18
10 Woodcut: Nave Nave Fenua 19
11 Idol with a Shell 22

THE PLATES

 1 Landscape
 2 The Seine at the Pont d'Iéna
 3 Study of a Nude
 4 Snow, Rue Carcel
 5 Self-portrait in front of an Easel
 6 Mandolin and Flowers
 7 The Beach at Dieppe
 8 The White Tablecloth (Pension Gloanec)
 9 Martinique Landscape
10 Young Breton Bathers
11 Woman with a Jug
12 The Vision after the Sermon
13 Old Women of Arles
14 The Schuffenecker Family
15 La Belle Angèle

16 The Yellow Christ
17 The Breton Calvary
18 Self-portrait with a Halo
19 Still-life dedicated to the Comtesse de N(imal)
20 Bonjour Monsieur Gauguin
21 Harvest: Le Pouldu
22 Marie Derrien
23 The Loss of Virginity
24 Vahine no te Tiare (Woman with a Flower)
25 Two Women on a Beach
26 I raro te Oviri (Under the Pandanus Palms)
27 Ta Matete (The Market)
28 Parau Parau (Conversation)
29 Tahitian Mountains
30 Nafea Faaipoipo (When are you to be married?)
31 Hina Tefatou (The Moon and the Earth)
32 Mahana no Atua (The Day of God)
33 Le Moulin David
34 Te Arii Vahine (The Female Chief)
35 Nave Nave Mahana (Days of Delight)
36 No te aha oe riri (Why are you angry?)
37 Portrait of the Artist (at Golgotha)
38 Nevermore
39 Te Rereioa (The Dream)
40 D'Où Venons Nous? Que Sommes Nous? Où Allons Nous?
 (Whence do we come? What are we? Where are we
 going?)
41 Faa Iheihe (Decoration)
42 The White Horse
43 Bouquet of Flowers
44 Three Tahitians
45 Still-life with the Painting 'Hope' by Puvis de Chavannes
46 Contes Barbares (Barbaric Tales)
47 Riders on the Beach
48 L'Appel (The Call)

Introduction

Our great interest in Gauguin today has come about not only because of the value of his work and its influence on modern art, but also because he had one of the most colourful lives of any artist in the nineteenth century. The impression which we receive from him is of a powerful nature struggling to fulfil its destiny, a man driven by himself to extremes and to self-destruction. On the one hand, the cultured European involved in the most sophisticated art movements of his time; on the other, the man who turned his back on western civilisation in order to become a savage, a Maori.

Paul Gauguin was born in Paris in 1848. His father was a journalist of liberal tendencies, and his mother, Aline Chazel, was the daughter of Flora Tristan, a political speaker and follower of Saint-Simon, of Peruvian-Spanish extraction. In 1849, a few months after the election of Louis Napoléon as President, the family left for Peru, where Aline had influential relations, the father dying en route. Although they only remained there for six years, it may well be that the boy retained impressions of that strange and remote land which, in later years, stirred his wanderlust, for in 1865 he enlisted in the merchant service and made voyages between Le Havre and South America.

In 1871, however, he left the sea and entered the Bertin bank in Paris as a stockbroker. By 1873 he was in a financial position to marry Mette Gad, a young Danish girl, and in the following years made a very comfortable income. He seems to have begun to paint in the summer of 1873, shortly before his marriage, encouraged perhaps by his guardian Gustave Arosa, who owned a fine collection of pictures by Corot, Delacroix, Courbet and the artists of the Barbizon School. Arosa's daughter, Marguerite, herself a painter, gave him instruction in the technique of painting in oils and went with him on Sundays to paint on the outskirts of Paris. At Bertin's he found that another employee, Emile Schuffenecker, had also developed an enthusiastic interest in painting. The two of them soon began to take their hobby so seriously that they went in the evenings to the Atelier Colarossi, one of the *ateliers libres* where artists could work freely without the discipline of the Académie des Beaux-Arts, to draw from the model and receive a certain amount of tuition.

Gauguin's early paintings were in the tradition of Daubigny, Corot, Jongkind and Courbet. Maturing rapidly, he exhibited a landscape at the Salon of 1876, but apparently never mentioned this to Arosa or to his wife.

The turning-point in his career was his meeting with Camille Pissarro, which seems to have taken place about 1877. The two became good friends and Pissarro gave Gauguin a great deal of useful advice; they even worked side by side, painting from the same motif, as Pissarro and Cézanne had done a few years before. With the older artist's encouragement, Gauguin began to form a fine collection of Impressionist paintings, including important works by Cézanne, Pissarro, Degas, Sisley, Guillaumin, Monet and Renoir; he also contributed to the last five Impressionist exhibitions of 1879–86. His works of this period show the typical Impressionist handling and broken colour similar to Pissarro, but without much personal quality. As Gauguin said later of Pissarro: 'He looked at everybody, you say? Why not? Everyone looked at him, too, but denied him. He was one of my masters and I do not deny him.' Gaining confidence, Gauguin began to tackle the human figure, getting his wife Mette and the maid to pose for him, or making studies from one or other of his children.

By all accounts, however, he was still not taken seriously as an artist, and probably himself felt uncertain of his powers. His first true success came when he exhibited *Study of a Nude* (plate 3) at the Impressionist exhibition of 1881 and earned the enthusiastic praise of the naturalist novelist and critic J. K. Huysmans: 'I don't hesitate to state that among the contemporary painters who have depicted the nude, none

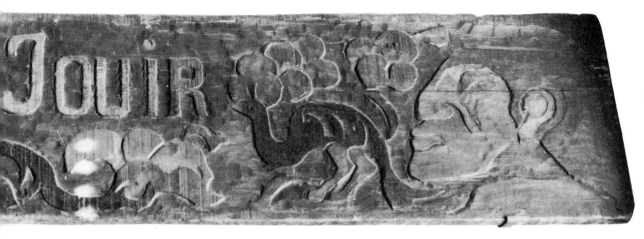

2 (and overleaf) *Carved panels from the door frame of Gauguin's house at Hivaoa. c.* 1902. Redwood. Louvre, Paris.

has yet given so vehement an expression of reality...' Gauguin became less modest, more assured; the stock market began to take second place. Nevertheless it came as a complete surprise to his wife when he suddenly announced in 1883 that he had decided to give up his job at the end of the year and become a full-time painter. About the beginning of January 1884 he moved with his family to Rouen, where he hoped to find a market for his pictures among the wealthy bourgeois, but he met with no success and after three or four months was in a precarious financial position. It was decided that Mette should return to Denmark to try to earn a living by teaching French and by making translations. Gauguin joined her there in December, but unfortunately was soon on bad terms with his wife's relations. Embittered by the hostility of the Gad family and by the failure of his one-man show in Copenhagen — a failure which he attributed partly to intrigue — he returned to Paris about the end of June 1885, leaving his wife behind.

The sacrifice of family, security and peace of mind to art had already begun. The successful business man was set on a path which would lead to renunciation of western civilisation, bitter poverty, an early death... and artistic greatness. 'I am a great artist...' he wrote to Mette later by way of explanation. 'I am a great artist and know it. It is because I know it that I have endured so many sufferings in order to proceed on my way, otherwise I should consider myself a brigand.'

Gauguin was not only influenced by Pissarro. He owned, for instance, at least five paintings by Cézanne including works from the period when Cézanne showed the most pronounced interest in simplification, pattern and the use of almost flat areas of colour surrounded by definite outlines. The influence of Cézanne can be seen in his still-life of 1885 reproduced as plate 6, and more strongly in certain other works of the same period. Afterwards, in 1890, he included

the still-life from his collection in the background of one of his portraits (plate 22), a picture which may be regarded as a kind of homage to Cézanne. He even took a fleeting interest in the innovations of the Neo-Impressionists, whose contributions had been the main attraction at the last Impressionist exhibition of 1886, though he soon turned against Neo-Impressionism and referred contemptuously to its exponents as 'confetti painters'. He insisted that the juxtaposition of complementary colours produced discord and not harmony. The very rigid, doctrinaire approach of Seurat and Signac was bound to clash with his own desire to liberate painting from every kind of restriction.

In June 1886, he moved to Pont-Aven in Brittany, which was then a favourite resort of painters. He was attracted to it partly because it was a country with archaic customs and partly because living there was very cheap. 'I love Brittany,' he said later, 'I find there the savage, the primitive. When my wooden shoes reverberate on this granite soil, I hear the muffled, heavy and powerful note I am seeking in painting.'

This urge to seek primitive, exotic terrain was carried a stage further in 1887 when he set out with the painter Charles Laval for Panama and Martinique. On Martinique the two artists lived in a negro hut, ate fishes and fruit, painted palm trees, banana trees and especially natives, and thought for a few blissful days that they had discovered Paradise. But Laval was taken ill with fever, while Gauguin himself suffered violent attacks of dysentery. Nevertheless, so far as work was concerned, this visit was not unprofitable. Gauguin made on Martinique a number of paintings which show him gradually freeing himself from Impressionism, simplifying his forms and, in the clear sunlight, using bolder colours including patches of blues, purple-mauves and reds (see plate 9). 'Despite my physical weakness,' he said, 'I have never before made paintings so clear, so lucid.'

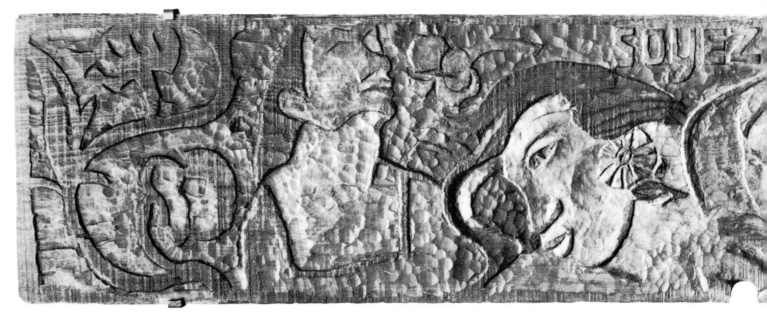

On his return from Martinique, Gauguin sought the hospitality of Schuffenecker (who had likewise given up his job at the bank to become a painter), then returned to Pont-Aven. In August he was joined there by Emile Bernard. Bernard had met Gauguin briefly during his first stay at Pont-Aven in 1886, but though arriving with an introduction from Schuffenecker, had not been well received — the two had in fact seen very little of each other. (At the pension Gloanec at Pont-Aven, Gauguin and his friends dined apart from the academic painters, and were referred to pugnaciously as 'The Impressionists'.) In 1888, however, Gauguin was very much interested in Bernard's recent paintings, executed in a style which Bernard and Anquetin had created under the influence of Japanese prints and Cézanne. This style was known as cloisonnism because of its areas of unbroken colour surrounded by bold outlines; the forms being made to stand out in clear-cut silhouette. When Gauguin saw Bernard's *Breton Women in a Field* he was, so Bernard assures us, greatly impressed, and forthwith painted his own *Vision after the Sermon* (plate 12) in which he used a similar convention reminiscent of Japanese prints and stained-glass.

The Vision after the Sermon depicts the moment after the sermon when the peasants, in their simplicity, almost imagine that they can see Jacob wrestling with the angel. The priest himself appears in the bottom right corner. Instead of a painting executed in front of nature, this is a work executed from memory and imagination — what Gauguin called an 'abstraction'. 'Real' figures — the peasants — are juxtaposed with imagined figures. The unreality of the scene is further enhanced by extremely arbitrary colour, in particular a background of flaming crimson. Instead of the typical Impressionist touch, there are flat or only slightly modelled areas of colour surrounded by bold strong outlines. The forms are simplified and in places given a distinct Art Nouveau curvilinear character. A slight suggestion of recession is created by the overlapping of the forms and by the diminution in scale of the figures, but the general effect is rather like a polychrome bas-relief. The wrestling figures themselves were derived from a Japanese print, probably from one of the groups of wrestlers in Hokusai's *Mangwa*. When this picture was finished, Gauguin offered it to a church near Pont-Aven — not out of piety but because he wanted to see its effect in the setting of the Romanesque and Gothic forms of the granite chapel. But it was refused by the priest.

The Vision after the Sermon is a key work for the understanding of Gauguin's development — and indeed for the development of modern art — as it marks his clear break with Impressionism and the naturalistic movement. This was the period when the Symbolist literary movement was getting under way, when writers of the new generation were attacking naturalism for its subservience to nature and were exalting the creative power of the imagination. Though Emile Bernard was only twenty years old, he was a reader of Baudelaire and a friend of young writers like Albert Aurier. 'Attentive to the Symbolist literary movement,' he wrote, 'I wanted a parallel kind of painting.' Gauguin from this time on became likewise anti-naturalistic and spoke in the highest terms of the god-like creative capacity of the artist. For instance, in August 1888, probably just after painting *The Vision after the Sermon*, he wrote to Schuffenecker: 'A word of advice: don't paint too much direct from nature. Art is an abstraction! Study nature, then brood on it and think more of the creation which will result, which is the only way to ascend towards God — to create like our Divine Master.' (There are echoes here of the ideas of Delacroix, Baudelaire and Edgar Allan Poe, all of whom Gauguin admired.) 'My latest works,' Gauguin went on, 'are on the right lines and I think you will find a new note, or rather the affirmation of my earlier experiments or synthesis of a single form and a single colour in which only the essential counts.'

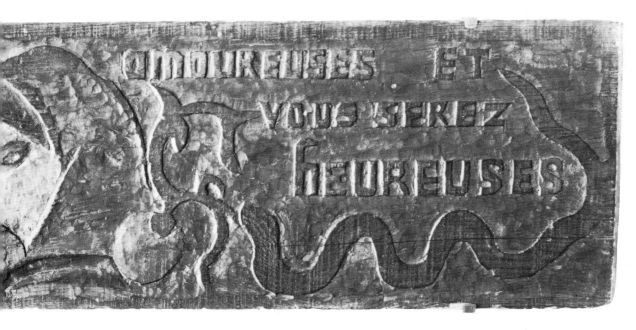

From the time, in 1891, when Gauguin was acclaimed the originator of this new style, Bernard waged a bitter campaign to establish that he was the innovator and influenced Gauguin, that he was the true founder of the School of Pont-Aven. And up to a point, this was true. There does not seem to be much doubt that he did exert a very definite influence on Gauguin's style with paintings such as the *Breton Women*; on the other hand Gauguin was receptive to his cloisonnism precisely because he had begun to develop along similar lines under the influence of Cézanne and Japanese prints. He carried the style to a new point of completeness and perfection and it is beyond question that it was Gauguin and not Bernard who influenced Sérusier and the Nabis.

Gauguin and Bernard had both met Vincent van Gogh in Paris in 1886–7. Although van Gogh had gone to Arles in February 1888, and was working there in isolation, he was by no means out of touch with events at Pont-Aven. Bernard sent him many letters describing his new pictures, some of which he even illustrated with sketches. Vincent was at this time preoccupied with the idea of establishing a community of painters in his yellow house at Arles similar to the associations of Japanese artists: he specially wanted artists to exchange self-portraits as a token of sympathy and live together in a state of mutual help. In exchange for one of van Gogh's self-portraits, Gauguin sent him a self-portrait with a portrait of Bernard in the background (now in the collection of Vincent's nephew, V. W. van Gogh), while Bernard sent a similar picture.

On 8 October 1888, Gauguin wrote to Schuffenecker: 'This year I have sacrificed everything, execution and colouring, for style, intending to compel myself to do something different from what I usually do. It is a transformation which has not borne fruit so far, but will, I think, bear it.

'I have done a self-portrait for Vincent, who asked me for it. I believe it is one of my best things: absolutely incom-prehensible (upon my word) so abstract it is. It looks at first like the head of a bandit, a Jean Valjean (*Les Misérables*), but it also personifies a disreputable Impressionist painter burdened for ever with a chain for the world. The drawing is altogether peculiar, being complete abstraction. The eyes, the mouth, the nose, are like flowers in a Persian carpet, thus personifying also the symbolical side. The colour is a colour remote from nature; imagine something like pottery twisted by the furnace! All the reds and violets streaked like flames, like a furnace burning fiercely, the seat of the painter's mental struggles. The whole on a chrome background sprinkled with childish nosegays. Chamber of a pure young girl. The Impressionist is such a one, not yet sullied by the filthy kiss of the Beaux-Arts (School).'

The painting is therefore done 'out of his head' not direct from nature; and the distortions are intended to convey symbolical ideas.

Ever since June van Gogh had been urging him to come to Arles, promising that his brother Theo, who was an art dealer with the firm of Goupil, would provide for him. Gauguin arrived at Arles later in that same month of October 1888.

The story of this tragic stay, which lasted two months, is well known. Gauguin and van Gogh lived in perpetual tension, arguing long into the night: the atmosphere was electric, dangerous. Though they used fairly similar conventions in art, their temperaments and tastes were strongly opposed. 'Vincent and I,' wrote Gauguin, 'are in general very little in agreement, above all with regard to painting. He admires Daumier, Daubigny, Ziem and the great Rousseau, whom I cannot stand. And on the other hand he detests Ingres, Raphael, Degas and all those whom I admire... He likes my paintings very much but when I have finished them, he always finds that I have made a mistake here, or there. He is romantic, while I am rather inclined towards a primitive

state. When it comes to colour, he is interested in the accidents of the pigment, as with Monticelli, whereas I detest this messing about with the medium.'

These differences are very apparent if one compares, for instance, Gauguin's *Old Women of Arles* (plate 13) with a rather similar painting by van Gogh, *Promenade at Arles — Souvenir of the Garden at Etten*. Gauguin uses simple, almost geometrical forms; those of van Gogh are twisting, flame-like, emotionally very highly charged. And whereas Gauguin's brushwork is very restrained, van Gogh's is extremely personal and plays an important part in the effect. 'It is odd,' wrote Gauguin, 'that Vincent feels the influence of Daumier here: I, on the contrary, see the Puvis [de Chavannes] subjects in their Japanese colourings. Women here with their elegant coiffure have a Grecian beauty. Their shawls, falling in folds like the primitives, are, I say, like Greek friezes.' Though the exact dates of these two pictures are not known it seems probable that Gauguin's was done first and that van Gogh used it as his starting-point — for, unlike Gauguin, he needed to have something in front of him while he was painting, either nature or another work of art. The fact that Gauguin was trying to impose his method of working from memory upon him was one of the factors which led to the final crisis.

Gauguin and van Gogh painted each other's portrait. When Gauguin finished his picture of van Gogh painting sunflowers, van Gogh exclaimed: 'It is certainly me, but it's me gone mad.' 'That very evening,' wrote Gauguin, 'we went to the café. He took a light absinthe. Suddenly he flung the glass and its contents at my head. I avoided the blow and, taking him bodily in my arms, went out of the café, across the Place Victor Hugo...' On Christmas Eve, after trying to attack Gauguin with a razor, van Gogh cut off his own ear and sent it as a present to a girl in a brothel. Gauguin thereupon summoned Theo to Arles by telegram; then returned to Paris, without seeing Vincent again.

In Paris he stayed once more with the Schuffeneckers. His portrait of the Schuffenecker family (plate 14) executed at this time shows how his style had become suppler. There is more space, the figures are more directly treated, yet the simplification and strength of design have been retained. Schuffenecker — 'the good Schuff' — a timid, well-meaning little man, is said to have been dominated by the assertive personality of Gauguin who practically took over the house while he was there, removed Schuffenecker's pictures and hung his own in their place, appropriated his studio and, at least once, even locked the studio door in his host's face.

Gauguin paid a number of visits to the Paris World's Fair, which opened in the spring of 1889, and was particularly interested in the Javanese village and the Hindu dancers. Though not included in the official retrospective exhibitions of French art, Gauguin, Bernard, Schuffenecker, Laval, Monfreid, Fauché, Anquetin and Roy found an opportunity to show some of their paintings unofficially within the grounds of the exhibition, at the Café Volpini, under the title 'Groupe Impressionniste et Synthétiste'. However, nothing was sold.

About the end of May 1889, Gauguin returned to Pont-Aven. This third stay in Brittany, which lasted except for a break of four months until November 1890, was a period of great activity. Now more than ever Gauguin tried to capture the rustic, primitive character of the Breton scene, its melancholy and remoteness, in paintings of peasants working in the fields and in pictures inspired by their naive religious faith. *The Yellow Christ* (plate 16), for instance, was based on the wooden polychrome sculpture of Christ in the ancient chapel of Trémalo, near Pont-Aven, which he transposed to an open-air setting. Some of the artists in Brittany had found in him an outward resemblance to the figure of the Messiah, suggested by his grave, imposing manner, his wearing of a short beard and moustache, and his position as the leader of a group of disciples. In several paintings, notably in *Christ on the Mount of Olives*, Gauguin seized on this resemblance as a means of alluding simultaneously to his own loneliness and suffering. *The Breton Calvary* (plate 17) — painted after he had left Pont-Aven and moved to Le Pouldu on the coast — was inspired by one of the stone calvaries characteristic of the region, most probably the Romanesque calvary at Nizon. The colours were used for their emotional effect, to enhance the mood of brooding melancholy and poetry. On a visiting card found among the papers of Albert Aurier, he made some notes evidently related to this composition:

'Calvary cold stone from the soil — Breton idea of the sculptor who explains religion through his Breton soul with Breton costumes — Breton local colour ... passive sheep', and

... 'All this in a Breton landscape i.e. Breton poetry his starting-point (colour brings the setting into a bluish harmony) etc... Cheerless to do — In contrast — (the human figure) poverty [illegible word] of life —'

Unlike the Impressionists, who tried to eliminate the literary element from their paintings, Gauguin was now very interested in subject-matter and was even prepared at times to define it in words (though words that were deliberately imprecise).

Gauguin moved to Le Pouldu towards the end of September 1889, and on 2 October settled at the inn kept by Mlle Marie Henry. He was accompanied by Meyer de Haan, a Dutchman who had ceded an interest in a prosperous biscuit factory in Amsterdam in return for a monthly allowance, in order to devote himself to the fine arts. He had begun as an academic painter, but had soon developed an enthusiasm for Impressionism. He became a great admirer of Gauguin, to whom he had been recommended by Camille Pissarro, and helped him financially, even keeping him supplied with tobacco. Under Gauguin's direction his own talents matured rapidly and he produced several interesting works.

At Le Pouldu, Gauguin was also joined by Sérusier and Filiger. Mlle Henry's inn became the centre of great artistic activity. The small living room was entirely transformed by Gauguin, de Haan and Sérusier. The windowpanes were covered with painted scenes of Brittany, like stained-glass windows. Wherever there was a space, mottoes and sayings were written on the plaster walls. Two landscapes and a portrait of Marie Henry by Meyer de Haan filled one wall; an over life-size bust of Meyer de Haan by Gauguin was placed on the mantelpiece; little statuettes and pots stood on shelves around the walls. A picture entitled *Bonjour, Monsieur Gauguins* (sic) was stuck on the upper panel of the door opening into the hall, and on the lower panel Gauguin painted *The Caribbean Woman* directly on the wood of the door. Outside the room, over the doorway, was a canvas entitled *The Terrestrial Paradise*.

A self-portrait and a portrait of Meyer de Haan were painted directly on the wooden doors of a massive cupboard, and the ceiling of the room was decorated with a painting of a swan and the head and shoulders of a woman (presumably a reference to the Jupiter and Leda myth) surrounded by the inscription 'Honi soit qui mal y pense!' Gauguin referred

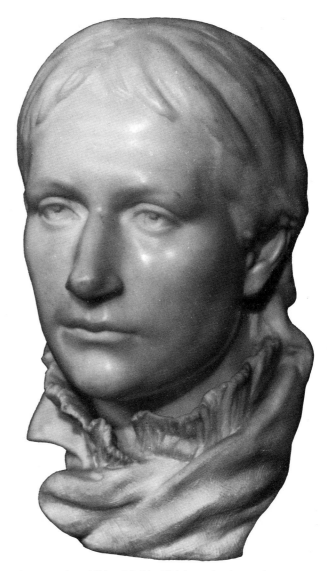

3 *Portrait of Mette*. 1877. White Marble. Height 13 in. (33 cm.). Courtauld Galleries, London.

sardonically in his self-portrait (plate 18) to the contrast between his outward resemblance to the Messiah and his arrogant and sensual inner nature, introducing as attributes not only a halo but the snake and apples symbolic of the Fall. In the companion picture, Meyer de Haan, who was bent and almost dwarf-like, was portrayed as the Devil. Thus the decorative scheme referred in part to the twin themes of Paradise and the Fall of Man.

It was at Le Pouldu in 1889 that Gauguin carved the bas-relief *Soyez amoureuses et vous serez heureuses* (figure 9) — a clear reference to his own ideas on free love. 'Gauguin (as a monster) seizing the hand of a protesting woman and saying to her: Be in love and you will be happy. The fox, an Indian symbol of perversity, then some little figures in the interstices.' Stylistically, this relief is developped out of such pictures as

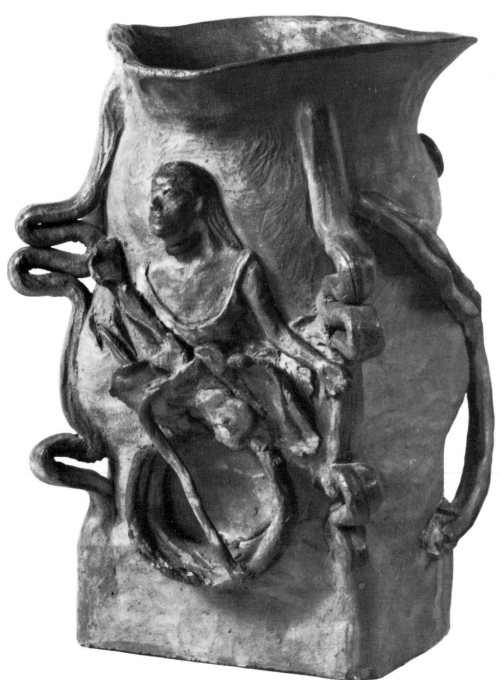

4 *Stoneware jug of Degas-like woman.* 1886-87.
Reddish-brown unglazed body.
Height 8½ in. (21.6 cm.).
Kunstindustrimuseet, Copenhagen.

5 (right) *Self-portrait jug.* 1889. Stoneware.
Height 7⅝ in. (19.3 cm.).
Kunstindustrimuseet, Copenhagen.

6 (far right) *Oviri. c.* 1894-5. Stoneware, glazed in parts.
Height 28¾ in. (73 cm).
Private Collection, Paris.

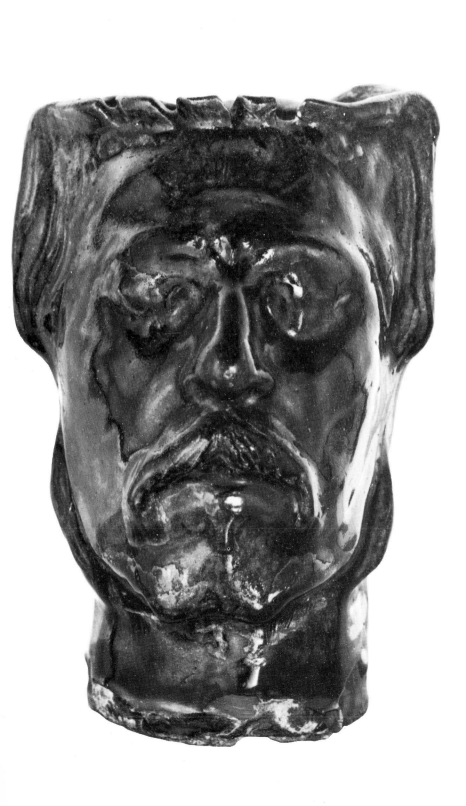

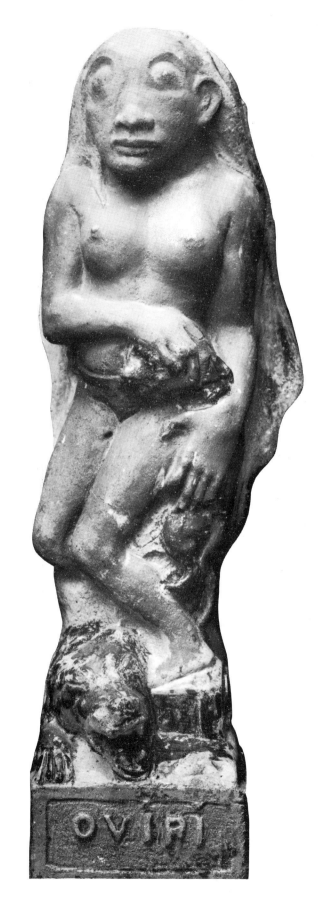

13

7 *Manao Tupapau* (The Spirit of the Dead Watches). *c.* 1893-95. Woodcut, coloured by hand and stencils. 8 $^7/_{16}$ × 20½ in. (22.7 × 52 cm.). Art Institute, Chicago.

The Vision after the Sermon, though it has a much more pronounced earthy and primitive character. The Art Nouveau curves present in *The Vision after the Sermon* likewise play a larger part in the design. One only needs to compare it with an Impressionist landscape painted three years before to see how radically Gauguin's conception of art has changed. In *Soyez amoureuses et vous serez heureuses* there is an imagined event, a projection of the artist's fantasy, a symbol, conceived in a manner which is entirely arbitrary.

Towards the end of 1890, Gauguin returned to Paris where he came into touch with Symbolist writers like Jean Moréas, Charles Morice, Stéphane Mallarmé, Paul Verlaine and Octave Mirbeau and was welcomed by them as the leading representative of Symbolism in painting. He became an habitué of the cafés where the Symbolist writers foregathered; he attended several of Mallarmé's 'Tuesdays'; Octave Mirbeau wrote the preface to the catalogue of the sale of 30 of his pictures at the Hôtel Drouot; and, shortly before his departure for Tahiti, a banquet was held in his honour at the Café Voltaire presided over by Mallarmé and attended by some thirty writers and artists of the Symbolist circle including Carrière, Redon, Morice, Moréas and Aurier.

Gauguin had been considering for some time the idea of going to the tropics, perhaps taking Emile Bernard, Laval or Meyer de Haan with him. His original intention had been to go once more to Martinique, or to Tonking or Madagascar, but Pierre Loti's novel *Le Mariage de Loti* and an official description of the enchantments of the Pacific islands made him decide on Tahiti.

To the creative artists of the Third Republic, who found themselves in a society where they had no proper place, where money values alone seemed to count, the age-old dream of a lost Paradise and Golden Age was particularly compelling. Artists felt themselves stifled in a hostile environment from which they needed to escape. Some escaped by turning inwards, by cultivating the world of their imagination and by cutting themselves off from ordinary life. Mallarmé, Villiers de l'Isle-Adam, Odilon Redon, Gustave Moreau did this. Others escaped by physically leaving Europe and going away to some remote part of the globe where more primitive and congenial conditions prevailed. Loti did this. Rimbaud did first one and then the other.

Gauguin was attracted to Tahiti however not only as a means of escape and renewal (by a return to origins) but also because it provided new subjects for his paintings and because life there was said to be free from all money difficulties '... one has only to raise an arm to find food'. In some respects he was to be cruelly disappointed. Tahiti was a French colony. On arriving at Papeete, the capital, he found that the Europeans were already established there. 'It was Europe, the Europe from which I had thought to free myself, and, into the bargain, all the irritating kinds of colonial snobbery.' After several months he moved some 25 miles from Papeete and went to live in a bamboo hut, with a thirteen-year-old Tahitian girl as his *vahine*; he dressed himself like the natives, went on fishing expeditions with them and tried to familiarise himself with their customs and way of thought. Whereas Loti, who had also visited Tahiti and taken a native wife, remained always the civilised westerner, conscious of his own superiority, Gauguin felt he had much to learn from them. He interested himself in the most primitive aspects of Tahitian life and the account which he wrote later of his

experiences — *Noa Noa* — characteristically plays down the fact that even the most remote country districts of Tahiti had already been partly Europeanised.

The pictures executed during this visit to Tahiti show a further move towards a more direct treatment. Instead of the large areas of uniform colour bounded by firm outlines of his Breton period, we find a definite modelling achieved through a more traditional use of nuances, and less conspicuous outlines. In most cases the foreground and middle distance are clearly established; there is no longer a bizarre cutting of figures by the edge of the canvas. The tendency is away from Japanese art, towards a more traditional treatment of space, modelling and composition. Certainly one never again finds paintings as stylised as *The Vision after the Sermon* or the *Self-Portrait with a Halo*.

A few of his Tahitian paintings — *Ia Orana Maria*, for instance — are of Christian themes, though the Biblical figures are enacted by Tahitians — Gauguin argued that the simple native folk would imagine them to be people like themselves. Another group of pictures is inspired by the traditional and pre-Christian religious beliefs and practices of the Polynesians. Gauguin stated in *Noa Noa* that his knowledge of the ancient pagan religions was mainly communicated to him by his wife. We know that this could not have been so. Not only were the religious secrets never revealed to women, but the traditional beliefs were more or less extinct by the time Gauguin reached Tahiti. His knowledge of them came from a book by a French consul to the South Sea Islands, named Moerenhout, published in 1837: *Voyage aux Iles du Grand Océan*. He transcribed passages from this book in his own manuscript *Ancien Culte Mahorie*, compiled about 1892, and used them again later almost word for word in the preparation of *Noa Noa*. His painting of *The Moon and the Earth* (plate 31), for instance, was clearly inspired by the legendary dialogue between Fatou and Hina (the spirits of the Earth and the Moon) regarding the eternity of Matter.

When Gauguin portrayed the Tahitians worshipping their idols, he therefore depicted a practice which had ceased at least fifty or sixty years before. Similarly he looked back nostalgically to the days when Tahiti was ruled by Maori kings and queens (cf. *Te Arii Vahine*, plate 34), and by the secret society of the Ariois, who practised the ideal of free-love. Not content with Tahiti of his own day, he also sought the primitive, pre-European civilisation.

When Gauguin returned to Paris in September 1893, his first desire was to organise an exhibition of the works he had brought back with him from Tahiti. The exhibition opened at Durand-Ruel's two months later, with a catalogue preface by Charles Morice. Though it aroused considerable curiosity and was very much admired by his writer friends, only eleven pictures were sold; the public was bewildered not so much by the technical originality of Gauguin's style as by its own ignorance of Tahitian history, religion and customs.

Fortunately Gauguin had a windfall: through the death of his uncle he received an inheritance of about 13,000 francs. This allowed him to rent an apartment in the rue Vercingétorix, an apartment which he decorated in characteristic fashion, just as he had previously decorated the living-room at Le Pouldu and his hut in Tahiti. (It seemed as though everything around him was turned into art.) He covered the windows of the tiny hall with paintings and embellished them with the characteristic motto 'Ici faruru' (here people make love). He painted the walls of his large studio chrome yellow and hung them with paintings by himself, van Gogh and others, and with barbaric boomerangs, axes and spears. On Thursday evenings he gave informal receptions which were attended by Julien Leclercq, August Strindberg, Charles Morice, Paul Roinard, Aristide Maillol, Paul Sérusier and many other writers and artists.

His own person was equally remarkable, for he strode the streets of Paris wearing a long frock coat of blue, with buttons of mother-of-pearl. Beneath this was a blue waistcoat which buttoned down the side and sported a collar embroidered in yellow and green. He wore a hat of grey felt with a sky-blue ribbon; he carried, in place of a cane, a stick decorated by himself with barbaric carvings and inset with a splendid pearl. To complete his accoutrement, he took with him his mistress, a half-Indian, half-Malayan girl known as Anna the Javanese.

In April 1894 they went to Brittany, where Gauguin was joined once more by artists sympathetic to his ideas, including Armand Seguin and Roderic O'Conor. One day, as he and Anna were walking with Seguin at Concarneau, some

boys began to throw stones at them and this ended in a brawl with four sailors of the locality. Gauguin was holding his own well enough until he caught his foot in a hole and in falling broke his ankle. Anna took advantage of his convalescence to return to Paris, where she ransacked his studio of everything except the pictures and then disappeared.

In September Gauguin told Monfreid that he had resolved to sell all his works and go and live for ever in the South Seas. The sale, which took place at the Hôtel Drouot the following February, proved a disaster: he had to buy back the majority of the paintings and barely covered his expenses. Fortified, however, by a contract with Lévy and Chaudet, who promised to ensure his financial security, he left for Tahiti in June 1895 — never to return.

His first visit to Tahiti had included much that was idyllic, the second was on the whole a time of misery: ill health and money difficulties plagued him almost without respite. His broken ankle had failed to heal completely and, in addition, he was suffering from the effects of syphilis. Within a few months, his legs were covered with open sores which caused intense irritation and for long periods the pain was such that he was quite unable to work. With no money from Lévy and only small, irregular sums from Chaudet, he had to rely on what his faithful friend and correspondent Daniel de Monfreid could sell for him. Repeatedly in debt, he suffered spells of intense depression which reached their climax in January 1898 when he tried to commit suicide by taking arsenic. It was only after March 1900, when Vollard made a contract with him and arranged to send monthly remittances, that his financial position began to improve.

The atmosphere of tragedy is reflected in a certain number of his paintings executed in these years. It is very apparent, for instance, in the *Portrait of the Artist (at Golgotha)* (plate 37) painted in 1896 at a time when a succession of misfortunes led him to exclaim: 'I am so demoralised, discouraged, that I don't think it possible anything worse could happen.' The tired, haggard face reveals his suffering and his weakened physical condition. It is clear also in the sombre, anguished colour harmonies of *D'Où Venons Nous? Qui Sommes Nous? Où Allons Nous?* (plate 41) and *The White Horse* (plate 40).

Gauguin has written of his Tahitian art in general:
'Wishing to suggest a luxuriant and wild nature, a tropical sun, which sets aflame everything around it, I have had to give my figures an appropriate setting. It is indeed life in the open air, but at the same time intimate; among the thickets, the shadowy streams, these whispering women in the immense palace decorated by Nature herself, with all the riches that Tahiti affords. Hence all these fabulous colours, this fiery yet softened and silent air.

'— But all that doesn't exist!

'— Yes, it exists, but as the equivalent of the grandeur, the profundity, of that mystery of Tahiti, when it has to be expressed on a canvas a metre square.

'She is very subtle, very clever in her naivety, the Tahitian Eve. The enigma hidden in the depths of her child-like eyes remains incommunicable... It is Eve after the fall, still able to walk naked without shame, preserving all her animal beauty as at the first day... Like Eve's, her body is still that of an animal. But her head has progressed with evolution, her mind has developed subtlety, love has imprinted an ironical smile upon her lips, and, naively, she searches in her memory for the *why* of present times. Enigmatically, she looks at you.'

Being himself a highly cultured western European, Gauguin was fascinated by the problem of Man's emergence from the primitive state, the life governed by instinct. Hence his recurrent references to Eve, to the Fall and to the Tree of Knowledge (themes which had begun to interest him even before his first visit to Tahiti). This can be seen for instance in his largest painting *D'Où Venons Nous? Qui Sommes Nous? Où Allons Nous?*, which Gauguin has described as follows — though warning 'Emotion first! understanding afterwards':

'In this big picture
 Where are we going?
Near the death of an old woman
A strange stupid bird concludes.
 What are we?
Day-to-day existence. The man of instinct wonders what all this means.
 Whence do we come?
Origins.
 Child.
 Common life.
'The bird concludes the poem by comparing the inferior

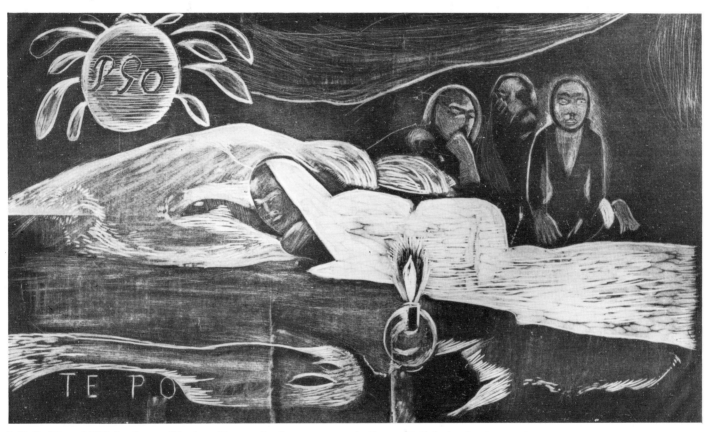

8 *Te Po* (Eternal Night). 1894-95. Woodcut. 8⅛ × 14 in. (20.5 × 35.5 cm). Courtauld Galleries, London.

being with the intelligent being in this great whole which is the problem indicated by the title.

'Behind a tree are two sinister figures, shrouded in garments of sombre colour, recording near the tree of knowledge their note of anguish caused by this knowledge itself, in comparison with the simple beings in a virgin nature, which might be the human idea of paradise, allowing everybody the happiness of living.'

Yet even with such a commentary as this, the precise significance of the painting remains obscure. As Gauguin himself said: 'My dream is intangible, it comprises no allegory.'

Gauguin contrasted his attitude to the literary content of his pictures with that of Puvis de Chavannes. 'Puvis explains his idea, yes, but he does not paint it. He is a Greek whereas I am a savage, a wolf in the woods without a collar. Puvis will call a picture *Purity* and to explain it will paint a young virgin with a lily in her hand — a hackneyed symbol, but which is understood by all. Gauguin, under the title *Purity*, will paint a landscape with limpid streams; no taint of civilised man, perhaps an individual'.

He rejected the academic symbolism of Puvis de Chavannes in favour of a more indirect, personal and evocative treatment. 'In painting, one must search rather for suggestion than for description, as is done in music.' Various contemporary poets were, of course, trying to do much the same — Ver-

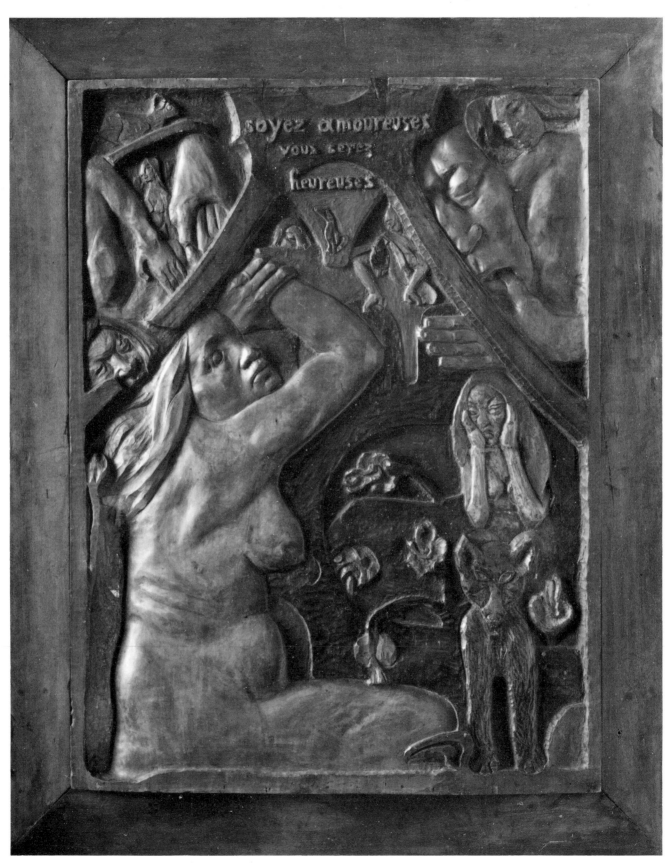

9 *Soyez amoureuses et vous serez heureuses* (Be in love and you will be happy). 1889. Wood relief, painted. 38¼ × 28¾ in. (97.1 × 73 cm.). Museum of Fine Arts, Boston.

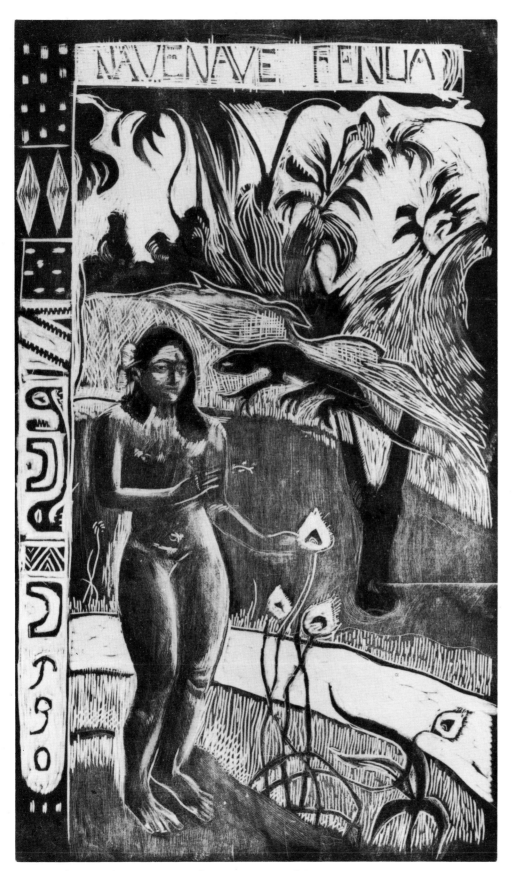

10 *Nave Nave Fenua* (The Delectable Earth). 1894-95. Woodcut.
 $13\frac{1}{2}$ × 8 in (34.5 × 20.3 cm.). Courtauld Galleries, London.

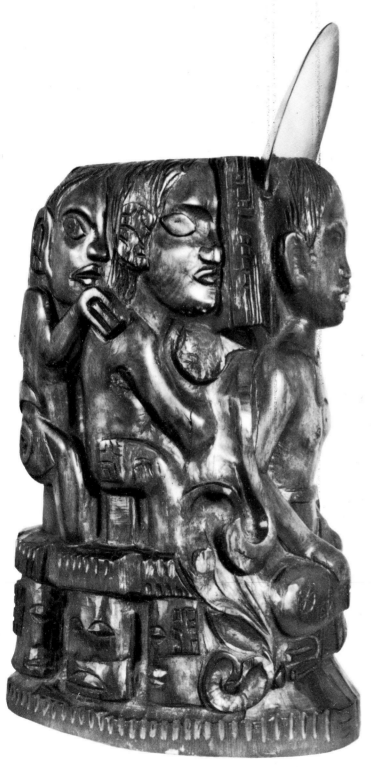

11 *Idol with a Shell*. 1893. Carved ironwood cylinder.
10⅝ × 5¼ in. (27 × 14 cm.). Louvre, Paris.

laine, for instance, for whose *Romances sans Paroles* Gauguin had a particular admiration; and also Mallarmé. In the avoidance of the anecdote, the substitution of a situation that is equivocal and suggestive, demanding the imaginative co-operation of the observer, there is much in common between Gauguin's attitude to his subject-matter and that of the Symbolist poets. Odilon Redon, the only other painter of his generation developing along these lines, was also in close touch with the Symbolist writers.

At the same time, Gauguin referred repeatedly to the colours in his paintings in 'musical' terms — 'think of the highly important musical role which colour will henceforth play in modern painting' — and he insisted that colours should be used arbitrarily for their direct effect upon the emotions. When questioned on this, he replied:

'They are intended, absolutely! They are necessary and everything in my work is calculated, premeditated. It is music, if you like! I obtain by an arrangement of lines and colours, with the pretext of some sort of subject taken from life or from nature, symphonies, harmonies which represent nothing absolutely real in the vulgar sense of the word, which express directly no idea, but which provoke thoughts as music provokes thoughts, without the help of ideas or images, simply through the mysterious relationships which exist between our brains and these arrangements of lines and colours.'

These theories, which were an extension of ideas to be found in the writings of Delacroix and Baudelaire, again led on to modern art, even to abstract painting.

'The painter hasn't the task, like a mason, of building, compass in hand, a house to a plan furnished by an architect. It is good for the young to have a model, but let them draw a curtain over it while they paint it. It is better to paint from memory. Then what is yours will be yours; your sensation, your intelligence and your soul will get across to the beholder...

'Who tells you that it is necessary to seek colour contrasts? What is sweeter for an artist than to pick out in a bouquet of roses the hue of each?... Seek harmony and not contrast...

'Let everything suggest calm and peace of mind. Thus avoid movement in a pose. Each of your figures should be static.

'Study the silhouette of each object...

'Do not finish a work too much, an impression isn't sufficiently prolonged to allow one to search for infinite detail...'

In place of the instantaneous, snap-shot view of the Impressionists, Gauguin avoids the momentary, the fleeting, the form in movement, and creates a world in which figures are charged with a slothful dignity. They look at us enigmatically, their eyes heavy with some secret thought.

In his reaction against Impressionism, Gauguin went for inspiration partly to Delacroix and Puvis de Chavannes (see, for example, plates 39 and 35). But he also — and this is part of his great historical importance as a pioneer of modern art — went to primitive and archaic sources. We have seen how he came to admire Romanesque sculpture and Japanese prints. While staying with Schuffenecker in Paris early in 1888, he started to make ceramics based on the primitive pottery in the Musée Guimet. Then, the following year, he introduced a Peruvian idol into his portrait *La Belle Angèle* (plate 15). In 1889 he brought back with him from the Javanese pavilion at the World's Fair a fragment of a frieze representing a dancer, and was inspired by it to carve a statuette. When he went to Tahiti he took with him at least two photographs of the frieze of the Javanese Temple of Barabudur and at least one of an Egyptian wall painting. From this Javanese bas-relief he took not only the pose of individual figures as in *Ia Orana Maria*, but the frieze-like conception of *Faa Iheihe* (plate 42) of 1898 and related works. The inspiration of Egyptian wall paintings is obvious in *Ta Matete* (plate 27) of 1892. Fascinated by Polynesian art, he carved idol-like figures in a similar convention. Thus Gauguin sought inspiration in primitive and archaic art in much the same way that the Mannerist artists of the sixteenth century turned to their Gothic forbears. In this respect he was of very great influence on the art of the twentieth century: for the discovery of the artistic merits of African woodcarving, so vital for the development of Cubism, was made by the Fauves and the German Expressionists under his direct influence.

Also important, though to a lesser degree, was his part in the revival of the woodcut, which in the middle of the nineteenth century had degenerated into a means for the mass-reproduction of pen drawings (such as those by Gustave Doré). Gauguin was one of the first to use large areas of black and to allow the tool marks to play their part in the design.

In 1901 he moved to the Marquesas Islands in order to live more cheaply and to find new subjects for his paintings. He had hoped to find a truly savage society there, but discovered instead that the European influences were once again causing a complete disruption of the traditional way of life. Within a few months of his arrival, he started to take the side of the natives against the white officials, inciting them not to send their children to the mission schools and protesting against the excessively heavy taxes and fines imposed upon them. A complaint about the corrupt behaviour of a policeman led to his being charged with libel and sentenced on 31 March 1903 to three months' imprisonment and a fine of 500 francs. At the time of his death on 8 May — a death which was almost certainly accelerated by the strain of these events — he was preparing to go to Tahiti to appeal against this sentence.

He had become a legend even in his lifetime. 'You are now,' so Monfreid wrote to him in December 1902, 'that unheard-of legendary artist, who from the furthest South Seas sends his disturbing, inimitable works, the definitive works of a great man who has as it were disappeared from the world.'

Recognition followed swiftly after his death. The memorial exhibition of his work at the Salon d'Automne of 1906, including no less than two hundred and twenty-seven paintings, drawings, sculptures and prints from his abundant production, silenced his detractors and provided a triumphant vindication of his long years of struggle.

Biographical outline

1848
7 June
Paul Gauguin born in Paris, 52 rue Notre-Dame-de-Lorette, son of a journalist, Clovis Gauguin, and his wife Aline (née Chazel). One sister, Marie, born 1847.

1849
Clovis Gauguin set off with his family for Peru, where his wife had influential relations. He died at sea on 30 October 1849 and was buried at Port Famine in the Straits of Magellan. His widow and the two children remained at Lima, Peru, until 1855.

1855
Mme Gauguin returned to France with the children. They lived until c. 1859 at Orléans in the family house owned by Isidore Gauguin, Paul's uncle, then moved to Paris where Mme Gauguin practised as a dressmaker in the rue de la Chaussée d'Antin from 1860 to 1865.

1865
Dec.
At the age of seventeen and a half, Paul Gauguin entered the merchant service as apprentice pilot on the *Luzitano*, on which he made two voyages between Le Havre and Rio de Janeiro.

Oct. 1866-
Dec. 1867
Second-lieutenant on the *Chili*, sailing between Le Havre and Valparaiso.

1867
7 July
Death of his mother Aline, who appointed Gustave Arosa as guardian of her two children.

Mar. 1868-
Apr. 1871
Served in the French navy aboard the cruiser *Jérome Napoléon* (later renamed *Desaix*).

1871
On his return to Paris, found that his mother's house at St Cloud had been gutted by fire during the Franco-Prussian War. Recommended by Arosa, he entered the office of the stockbroker Bertin, in Paris, rue Laffitte (a street in which there were also art galleries). Then, or a little later, met Emile Schuffenecker, who was also an employee at Bertin's.

1873
Summer
Began to paint. Encouraged by Marguerite Arosa, his guardian's daughter, herself a painter who taught him the technique of painting in oils.

22 Nov.
Married Mette Sophie Gad, a Danish girl aged 23.

1874
Birth of their first child, Emil (31 Aug.).
Was becoming more and more interested in drawing and painting; went to the outskirts of Paris to paint on Sundays and sometimes visited the Atelier Colarossi with Schuffenecker in the evenings to draw from the model.

1876
Had a landscape accepted at the Salon.

1877
Moved in the spring to a larger apartment at 79 rue des Fourneaux, rented from the sculptor Paul Bouillot. Began to try his hand at modelling and carving under Bouillot's direction. About this time met Camille Pissarro and began to form a collection of Impressionist pictures. Was making a large income on the stock exchange.

24 Dec.
Birth of his daughter Aline.

1879
April
Exhibited a sculpture in the 4th Impressionist exhibition (invited by Pissarro and Degas), though not listed in the catalogue.

8 May
Birth of his second son, Clovis.

Close friendship with Pissarro; apparently worked with him at Pontoise and Osny in the holidays. Was spending more and more time in the company of artists and dealers.

Exhibited at the 5th Impressionist exhibition. Monet declined to exhibit, protesting that 'the little band has become a banal school which opens its doors to the first dauber that comes along'.
Rented a house with a studio, 8 rue Carcel.

Exhibited at the 6th Impressionist exhibition,

when his *Study of a Nude* was highly praised by Huysmans.

Birth of his third son, Jean.

Spent the summer holidays with Pissarro and Cézanne at Pontoise. Towards the end of the year told Pissarro of his ambition to retire from business and devote himself full-time to painting.

Played an active part in the organisation of the 7th Impressionist exhibition (in March). Huysmans commented: 'M. Gauguin is not progressing alas...'

In the course of the winter 1882-3 again visited Pissarro at Osny and painted with him.

Resigned his job at Bertin's (Jan.) but apparently worked part-time until the end of the year. With Pissarro at Osny to spend the holidays and make some studies.

Birth of his fourth son, Paul (Pola).

(?) Jan.	Moved to Rouen, where he rented a house for a year. His resources were exhausted after three or four months and his attempts to sell his pictures were in vain.
early Aug.	Mette left by sea for Denmark with Aline and the youngest of the boys, leaving him at Rouen with the other boys and the maid.
Dec.	Gauguin arrived in Copenhagen. He had arranged to work as Scandinavian agent for Dillies et Cie, manufacturers of tarpaulins, and continued to work for them until about May 1885.
1885	Lived in an apartment at Gl. Kongevej 105, then moved on 22 April to Norregade 51.
1-6 May	Short one-man show at the Society of the Friends of Art, Copenhagen, was ignored by the press and a total failure.
(?) end June	Embittered by this lack of success and the hostility of his wife's family, he returned to Paris, taking Clovis with him.
Sept.	Spent several days at Dieppe (where he met and

quarrelled with Degas), then may have gone to London for two or three weeks.

Oct.	Rented a small apartment, 10 rue Cail, Paris. Tried to get employment as assistant to Bouillot; also considered seeking a minor post on the stock exchange.
	Mette began to sell pictures from his collection. Spent the winter in miserable conditions.
1886	With Clovis ill in bed, worked as a bill-poster to earn money to support them both. When Clovis had recovered, put him in a *pension* at Antony (Seine).
May-June	Represented in the 8th and last Impressionist exhibition.
18 June	Had a violent quarrel with Seurat over the use of Signac's studio.
late June- 13 Oct.	Made his first visit to Pont-Aven, staying at the Pension Gloanec. The other boarders included Charles Laval and various English and American painters. First, but unproductive, meeting with Emile Bernard in August.
Oct.-Dec.	On his return to Paris in October, settled at 257 rue Lecourbe. Unable to sell any of his own works, living meagrely on the sale of pictures from his collection. Began to make ceramics in collaboration with the ceramist Ernest Chaplet. Saw much of Degas, but now avoided Pissarro and the Neo-Impressionists. Met Vincent van Gogh. Spent most of December in hospital.
1887	Apparently taught at the Académie Vitti.
early April	Told Mette he was going to Panama 'to live as a *savage*'. She came to Paris to see him before his departure and to collect Clovis.
10 April	Left St Nazaire with Laval for Panama via Guadeloupe and Martinique, arriving in Panama at the end of April (with the intention of moving on to Taboga). Failed to get help from his brother-in-law Juan Uribe, who was in business there. Worked as a labourer on the canal to

raise money to go to Martinique, while Laval worked as portrait painter.

June — On suspension of part of the work on the canal, both moved to Martinique, where they lived in a native hut. Laval stricken with fever.

July-Aug. — Ill with dysentry contracted in Panama.

Sept. — Began to paint again.

Nov. — Worked his passage back to France on a sailing vessel (Laval remaining a few months longer). Went to stay with Schuffenecker, 29 rue Boulard; met Daniel de Monfreid there. Saw Vincent van Gogh again.

1888
Jan. — Making ceramic sculpture with Chaplet. Exhibited with Pissarro and Guillaumin at Goupil's (the branch run by Theo van Gogh).

Feb.-Oct. — At Pont-Aven, Pension Gloanec. His health still troubling him and very pressed for money.

June — Received a letter from Vincent van Gogh inviting him to Arles. Joined at Pont-Aven by Laval, Moret, Chamaillard, Schuffenecker and (in August) by Emile Bernard. Painted *The Vision After the Sermon*; attracted by Bernard's sister Madeleine.

Sept. — Gave instruction to Sérusier, who painted the 'talisman' under his direction.

Oct. — One-man show at Goupil's.

20 Oct. — Joined Vincent van Gogh at Arles on the understanding that Theo would take part of his production in exchange for a monthly allowance.

Dec. — Made a day trip to Montpellier with him to visit the museum.

24 Dec. — Van Gogh cut off his own ear. Summoned Theo to Arles and returned with him to Paris after Christmas; went to stay with the Schuffeneckers.

1889
Jan.-Mar. — Paris, 25 Avenue Montsouris. Made a set of eleven lithographs on zinc.

Feb. — Exhibited with Les XX at Brussels for the first time.

(?) Mar. — Visited the World Fair and was particularly interested in the Javanese and Indonesian art.

Exhibited with Laval, Fauché, Schuffenecker, Anquetin, Monfreid, Bernard and Roy at the Café Volpini as 'Groupe Impressionniste et Synthétiste'.

end May or early June — Returned to Pont-Aven, Pension Gloanec, then moved shortly afterwards to Le Pouldu for about a month; back at Pont-Aven late June–late September. Accompanied by Meyer de Haan, and for part of the time Sérusier, Laval, Chamaillard, Filiger, Moret and Jourdain. Helped financially by de Haan in return for advice on painting.

late Sept. — Moved to Le Pouldu, staying first at the Auberge Destez-Portier.

2 Oct.-(?)Feb. — At the inn run by Mlle Marie Henry; decorated the living room with the assistance of de Haan and Sérusier. Made unsuccessful attempts to get a post at Tonking.

31 Oct.-11 Nov. — Exhibition at the Society of the Friends of Art, Copenhagen, of French and Scandinavian Impressionists drawn mainly from the collection of Mette and including works by Gauguin.

1890
(?) 8 Feb. — Returned to Paris and called on Theo van Gogh to seek some kind of employment. Again stayed with the Schuffeneckers, now living at 14 rue Durand-Claye. Considered going to Madagascar or Tahiti.

June-7 Nov. — In Brittany with de Haan, moving between Pont-Aven and Le Pouldu; joined in July by Filiger and (briefly) by Sérusier. Squabbled with de Haan over the affections of Mlle Henry. Left her inn on 7 November owing more than 300 francs, abandoning his paintings there; returned to Paris.

Dec. — In Paris, staying with the Schuffeneckers. Met Moréas, Morice, Carrière and other leading Symbolists and joined them at the Café Voltaire, the Côte d'Or, etc.

1891
1 Jan — His lithograph of Jean Moréas inscribed 'Soyez Symboliste', published in *La Plume*.

Introduced by Morice to Mallarmé; attended his 'Tuesdays' and etched his portrait.

3 Feb. Attended the banquet of the *Pèlerin Passionné* in honour of Moréas.

Quarrelled with Schuffenecker and was asked to leave; moved to a hotel, rue Delambre; invited by Monfreid to paint in his studio, 55 rue du Château.

Exhibited with Les XX at Brussels.

Great activity to advertise his sale; articles by Mirbeau and Aurier.

23 Feb. His sale of 30 paintings at the Hôtel Drouot realised about 9,350 frs., but led to a break with Emile Bernard.

7 Mar. Arrived in Copenhagen to see his wife and children for what proved to be the last time (back in Paris by 20 March, perhaps by 15th).

23 Mar. Banquet in his honour at the Café Voltaire presided over by Mallarmé.

26 Mar. The Ministry of Public Instruction and Fine Arts granted him, at his request, an 'honorary artistic mission' in Tahiti, which enabled him to get a passage at a reduced rate.

1 April Left Marseilles for Tahiti. Travelled via Melbourne, Sydney and Noumea.

21 May Performance at the Théâtre d'Art for the benefit of Verlaine and Gauguin only made a profit of 100 frs., all of which was given to Verlaine.

23 May Joyant, Theo's successor at Goupil's, gave 853 frs. to Morice, which he failed to forward.

9 June Arrived in Tahiti. Took a plank house in Papeete and tried to learn the Maori language; death of Pomare V, the last king of Tahiti, shortly after his arrival; tried, with little success, to obtain portrait commissions from the white settlers.

Aug. In hospital, coughing blood and with heart trouble (possibly due to syphilis).

(?) Sept. Stayed for several weeks at Paea, then moved from Papeete to Mataiea, some 25 miles away, where he lived in a bamboo hut.

1892 Applied unsuccessfully for the post of magistrate
Jan.-Feb. in the Marquesas Islands.

Mar. 'My life is now that of a savage ... I am working more and more'.

May have begun at this time to read Moerenhout's book on Tahitian lore and compile his own *Ancien Culte Mahorie*.

June Thought of leaving though wished to stay. Had received no money from France and was very hard up; sold a painting for 400 frs., in Papeete to the captain of a schooner. Took a thirteen-year-old girl Teha'amana as his *vahine*.

12 June Wrote to the Director of Fine Arts in Paris, asking to be repatriated; owing to administrative difficulties this was not effected until the following year.

Aug. Sold two small wood sculptures in Papeete for 300 frs.

Sept. One of his Tahitian pictures (*Woman with a Flower*) exhibited at Goupil's.

Nov. Received 300 frs. from Monfreid.

Dec. The dealer Portier returned his unsold Gauguins to Monfreid as none of his clients was interested.

1893 Subsisting on breadfruit and water; his eyesight
Feb.-Apr. impaired, did very little painting for two months or more.

21 Mar. Received 700 frs. from Mette and paid his debts in the locality.

24 Mar. Before leaving his post at the Goupil Gallery, Joyant returned to Monfreid all Gauguin's paintings, ceramics, etc., that were on consignment there.

26 Mar. Exhibition of some 50 of his paintings, sculptures and ceramics opened in Copenhagen in the building of Free Exhibitions; was simultaneously represented in another exhibition there at the Kleis Gallery. These exhibitions aroused great interest and several works were sold.

(?) May Returned to Papeete, living in a rented house.

14 June Repatriated to France via Noumea and Sydney.

30 Aug. Arrived at Marseilles with 4 frs. in his pocket;

received money from Sérusier.

In Paris, rented a room at 8 rue de la Grande Chaumière and was allowed by Alphonse Mucha to work in his studio there.

Sept. Called to Orléans in connection with an inheritance of about 13,000 frs. from his uncle Isidore Gauguin.

Nov. Exhibition of his Tahitian works (44 paintings and 2 sculptures) at the Galerie Durand-Ruel; eleven paintings sold. The catalogue preface was by Charles Morice, with whom he began to write *Noa Noa*.

Dec. Rented a studio, 6 rue Vercingétorix. Gave receptions on Thursdays attended by, among others, Leclercq, Morice, Roinard, Mollard, Maillol, Seguin, O'Conor, Zuloaga, Monfreid, Chamaillard, Maufra and Strindberg.

1894 Exhibited with the group of La Libre Esthétique at Brussels.

Feb. Made a brief trip to Brussels, Antwerp and Bruges with Julien Leclercq; attended the opening of La Libre Esthétique and admired the Memlings at Bruges. Anna the Javanese joined him as his mistress.

early May Stayed at Le Pouldu with Anna for several weeks as guests of the Polish painter Slevinsky, then moved to Pont-Aven, where he settled at the Pension Gloanec; accompanied at various times by Chaudet, Seguin, Chamaillard, Moret, Loiseau and O'Conor.

25 May While walking with Anna, Seguin and O'Conor at Concarneau was involved in a brawl with sailors in the course of which he broke his right leg just above the ankle. This caused intense pain and for three months he was apparently unable to paint. During his convalescence, made woodcuts from memory of some of his Tahitian pictures.

(?) Sept. Anna returned to Paris, where she ransacked his studio of everything except the pictures and then disappeared.

20 Sept. Wrote to Monfreid that he had resolved to go and live for ever in the South Seas; hoped to leave with Seguin and O'Conor.

14 Nov. His action against Mlle Henry for the recovery of his pictures left at Le Pouldu in 1890 was dismissed by the court at Quimper. Shortly afterwards, returned to Paris, rue Vercingétorix. Worked part of the time in O'Conor's studio, 102 rue du Cherche Midi.

Dec. Held a small private exhibition of his works in his rue Vercingétorix studio.

1895
17 Jan. Attended the banquet in honour of Puvis de Chavannes.

18 Feb. His sale (largely of Tahitian works) at the Hôtel Drouot was a disaster; he had to buy back most of the paintings.

Mar.-Apr. Ill with a syphilitic infection.

29 June Left Paris for the last time; sailed to Tahiti via Sydney and Auckland.

8 Sept. Arrived in Tahiti to find Papeete increasingly Europeanised. At first intended to move the next month to the Marquesas Islands, but instead built a large hut in the country at Punaauia.

Nov. In despair because no one had paid the money due to him.

1896 Took the fourteen-year-old Pau'ura as his *vahine*.

(?) Jan.
Mar.-
May His broken ankle causing much pain; had also developed running sores on his legs. Wrote in May that he was in desperate need of money, at the end of his strength and resources.

June Asked Monfreid and Maufra to find fifteen people interested in his paintings who would contribute 160 frs. a year each in return for a painting apiece.

July In hospital but with no money to pay the bill. Left hospital a month later only partly cured and owing 140 frs. Schuffenecker circulated a petition (signed by Puvis de Chavannes, among others) asking the State to aid him; was sharply reproved by Gauguin.

Aug.-Sept. Obtained a post as drawing-master to the daughters of a wealthy lawyer, Auguste Goupil.

Oct.	Received 400 frs. and paid some of his debts. 'I am so demoralised, discouraged, that I don't think it possible anything worse could happen'.
Nov.	Feeling somewhat better.
27 Dec.	Received 1,200 frs. from Chaudet with the promise of a further 1,600 frs., and was out of debt.
1897 Jan.	Apparently re-entered hospital in the hope of being completely cured.
Feb.	Feeling much better, was hard at work.
24 Feb.- 1 Mar.	Exhibited with the group of La Libre Esthétique at Brussels.
Apr.	Received a letter from his wife announcing the death of Aline, his favourite child. Through his landlord's death, was obliged to move to another site and reconstruct his house; had not received the 1,600 frs. promised by Chaudet.
May	Borrowed 1,000 frs. from the bank for a year to buy land and construct a new house.
July	Had exhausted his money and was becoming very worried about his debts. Ill with sores on his legs and suffering from double conjunctivitis, was unable to paint for some four months.
Aug.	Wrote a harsh letter to Mette, who broke off the correspondence.
Sept.	Now owed 1,800 frs. and had no more credit.
Nov.	Was vomitting blood; told Monfreid he wanted only silence, to be left in peace and forgotten.
Dec.	In despair because of growing debts, ill-health and the difficulty of selling his works, began to paint *D'Où Venons Nous?* as a last great painting. Living on water, guavas and mangoes.
(?) 31 Dec.	Tried to commit suicide by taking arsenic, but took an overdose which caused him to vomit and throw up all or most of the powder.
1898 Jan.	Still ill from the effects of the poison. Received 700 frs. from Chaudet and 150 frs. from Maufra and paid his most pressing creditors.
Mar.	Calmer and feeling better. Though no longer pursued by creditors, was worried by the debt due to the bank in May.

Apr.	Having no money at all, took a post as draughtsman in the Public Works Department at Papeete. Said that he had ceased to paint until things became normal again.
May	Received 575 frs. from Monfreid; also obtained an extension of credit on the 1,200 frs. now owing to the bank.
Aug.	Received 700 frs. from Chaudet.
Sept.	In hospital for three weeks to have his foot treated.
Oct.	Received 1,300 frs. from Monfreid and Chaudet. Vollard bought four pictures from Monfreid for 600 frs.
Dec.-Jan.	Exhibition of his recent paintings at the Galerie Vollard, including *D'Où Venons Nous?*
Dec.	Vollard bought nine more paintings from Monfreid for 1,000 frs.
1899 Jan.-Feb.	Received money from Monfreid and was able to return to Punaauia. Found that rats had destroyed the roof of his hut and that some drawings and an unfinished canvas had been destroyed by cockroaches. Still too ill to paint. Greatly upset that Vollard had obtained a number of his recent works at such low prices.
21 Apr.	Pau'ura bore him a son, Emile.
May	Spent money on constructing a well and had only 100 frs. in hand.
June	Had to obtain his bread on credit. Began to contribute articles to *Les Guêpes* (a monthly periodical published at Papeete), attacking the colonial administration and in particular the procurator.
Aug.	Had no more canvas and was still too discouraged to paint. Published the first issue of his own satirical periodical *Le Sourire*; continued to issue this monthly until April 1900.
Sept.	Started to work again, taking up a number of things left unfinished.
Dec.	Suffering from the sores on his feet and in debt.
1900 Jan.	Learnt of the death of Chaudet, who owed him about 2000 frs. Received a letter from Vollard

offering to buy watercolours, flower pictures, perhaps his entire output. Asked in reply for a monthly allowance of 300 frs. against pictures to be credited at 200 frs. each. Also received a letter from Prince Bibesco containing 150 frs. for a small painting. Was in great need of money. Agreed to act as editor of *Les Guêpes*, which he continued to edit until August 1901; became very much involved with local politics and journalism.

Mar. Vollard accepted his terms and sent a first remittance.

May Received 750 frs. from Monfreid and 300 from Vollard; paid his debts and had a little in hand. Also received an offer from Bibesco to take works in place of Vollard on the same terms. Said he had been unable to paint for six months.

Aug. Ill with influenza.

Nov. Because Vollard was in arrears with his monthly remittances, had to work as an accountant to pay for a new roof on his hut and to buy food. Again his painting was interrupted.

Dec. Received 1,200 frs. from the collector Gustave Fayet in payment for two pictures. Entered hospital.

1901 In hospital, very ill with eczema on his feet, and
Jan.-Feb. influenza.

April Again unwell with influenza.
The monthly remittances from Vollard now enabled him to live in comparative comfort, though the cost of living in Tahiti was rising sharply. In order to live more cheaply and to find new subjects for his paintings, decided to move to the Marquesas Islands.

7 Aug. Sold his property for 4,500 frs.

10 Sept. Embarked for the Marquesas Islands.

16 Sept. Arrived at Atuona, the chief village of Hivaoa (La Dominique).

27 Sept. Bought a demi-hectare of land there from the mission. His house, known as the 'Maison du Jouir' (House of Pleasure), was completed by the end of October; it was in the centre of the village but surrounded by gigantic tropical plants.

Nov. A fourteen-year-old girl, Vaeoho, came to live with him.

1902 Work progressing well, though his health still
Mar. poor. Complained to the Governor of the French Possessions in the South Seas that the high taxation was of little direct profit to the islands, and refused to pay his taxes.

May Bought a trap for driving around the village, as his bad ankle made it very painful for him to walk.

Aug. Now out of debt and had even saved a little; the cost of living much lower than on Tahiti. Was beginning to spend considerable sums on choice food, wine, absinthe, etc. Incited the natives not to send their children to the mission schools and to withhold payment of taxes; also quarrelled bitterly with the Catholic bishop.

23 Aug. Wrote to Monfreid that he contemplated returning to France to be cured and then going on to paint in Spain for several years.

Sept. Sent the manuscript of *Racontars de Rapin* to André Fontainas in the hope that it would be published in the *Mercure de France*. Also revised his essay on *The Modern Spirit and Catholicism*.

14 Sept. Vaeoho bore him a daughter.

Oct. Received 600 frs. from Monfreid. Had received nothing from Vollard since April.

1902-1903 Wrote *Avant et Après*.

1903 The 'Maison du Jouir' slightly damaged by a
13 Jan. cyclone.

Feb. Wrote to the administrator of the Marquesas Islands to denounce the corrupt behaviour of a gendarme on a neighbouring island; this led to his being charged with libel. Also complained (in March) to the visiting inspectors about the unfair methods of administering justice to the

natives. Because of the suffering caused by his eczema, he had been unable to paint for nearly three months; his eyesight was also giving him cause for serious disquiet.

31 Mar. Was found guilty of libel and sentenced to a fine of 500 frs. and three months' imprisonment.

April Planned to go to Tahiti to appeal against the sentence; anxious to raise money to meet the expenses. Told Monfreid: 'All these preoccupations are *killing me*.'

8 May Died at Atuona.

SELECTED READING LIST

Georges Wildenstein, *Gauguin*, Paris 1964, vol. 1.

Christopher Gray, *Sculpture and Ceramics of Paul Gauguin*, Baltimore 1963.

Maurice Guérin, *L'Oeuvre gravé de Paul Gauguin*, Paris 1927, 2 vols.

Merete Bodelsen, *Gauguin's Ceramics*, London 1964.

Paul Gauguin, *Noa Noa*, Paris 1929.

Paul Gauguin, *Avant et Après*, Paris 1923; translated as *The Intimate Journals of Paul Gauguin*, London 1952.

Gauguin, *Racontars de Rapin*, Paris 1951.

Paul Gauguin, *Ancien Culte Mahorie* (ed. R. Huyghe), Paris 1951.

Paul Gauguin, *Cahier pour Aline* (ed. S. Damiron), Paris 1963.

Lettres de Gauguin à sa Femme et à ses Amis (ed. M. Malingue), Paris 1946.

Lettres de Gauguin à Daniel de Monfreid (ed. Mme Joly-Segalen), Paris 1950.

Paul Gauguin, *Letters to Ambroise Vollard and André Fontainas* (ed. J. Rewald), San Francisco 1943.

Jean de Rotonchamp, *Paul Gauguin 1848-1903*, Weimar and Paris 1906; Paris 1925.

Charles Morice, *Paul Gauguin*, Paris 1919.

Charles Chassé, *Gauguin et le Groupe de Pont-Aven*, Paris 1921.

Charles Chassé, *Gauguin et son Temps*, Paris 1955.

Arsène Alexandre, *Paul Gauguin, Sa Vie et le Sens de Son Oeuvre*, Paris 1930.

Pola Gauguin, *My Father Paul Gauguin*, London 1937.

John Rewald, *Gauguin*, Paris - London - New York 1938.

Emile Bernard, *Souvenirs inédits sur l'Artiste Paul Gauguin et ses Compagnons*, Lorient 1941.

Maurice Malingue, *Gauguin*, Paris 1948.

Gauguin: Sa Vie, Son Oeuvre (ed. G. Wildenstein et al), Paris 1958.

Robert Goldwater, *Paul Gauguin*, London n.d.

Bengt Danielsson, *Gauguin in the South Seas*, London 1965.

Denys Sutton, 'La Perte du Pucelage by Paul Gauguin' in *Burlington Magazine*, XCI, 1949, pp. 102-5.

Bernard Dorival, 'Sources of the Art of Gauguin from Java, Egypt and Ancient Greece' in *Burlington Magazine*, XCIII, 1951, pp.118-23.

Merete Bodelsen, 'The Dating of Gauguin's Early Paintings' in *Burlington Magazine*, CVII, 1965, pp. 306-13.

John Rewald, *Post-Impressionism from Van Gogh to Gauguin*, New York 1956 (contains extensive bibliography).

Notes on the plates

(All the paintings reproduced are in oil on canvas unless otherwise stated)

Plate 1 *Landscape*. 1874-5. 19⅞ × 32⅛ in. (50.5 × 81.5 cm.). Fitzwilliam Museum, Cambridge.
One of the Gauguin's earliest surviving pictures. The inscription has sometimes been read as '7-73' (presumably July 1873) but is more probably '74-75' which accords better with what is known of his early development: he only seems to have begun to paint in the summer of 1873 and his first pictures were much more tentative.
The scene is perhaps on the outskirts of Paris or in Normandy. It shows the influence of early Corot and the Barbizon painters. Clearly painted on the spot, out of doors.

Plate 2 *The Seine at the Pont d'Iéna*. 1875. 25¼ × 36¼ in. (64 × 92 cm.). Louvre, Paris.
In this case the relationship seems closest to Jongkind; there is still no definite trace of Impressionism. A very accomplished rendering of wintry light and open space.

Plate 3 *Study of a Nude* (The Seamstress). 1880. 45 × 31¼ in. (114.5 × 79.5 cm.). Carlsberg Glyptotek, Copenhagen.
The model for this picture is sometimes said to have been Justine, the maid who looked after Gauguin's children; but Gauguin himself refers to her as Suzanne and it is probable that she was just a professional model. He painted her in the act of doing her mending, an attitude so natural and unselfconscious that it makes even the nudes of Courbet look rhetorical. There is a marked interest in the fall of light, but the colours are rather drab.
When exhibited at the Impressionist exhibition in 1881, this picture was highly praised by Huysmans for its realism. It was afterwards purchased from Mette in 1892 by the Danish painter Philipsen.

Plate 4 *Snow, Rue Carcel. c.* 1883. 23⅝ × 19⅝ in. (60 × 50 cm.). Carlsberg Glyptotek, Copenhagen.
The artist's garden, 8 rue Carcel, Paris. A larger version of the same scene, dated 1883 and with two figures added in the foreground, is in the collection of Mrs Eva Kiaer, Copenhagen. It is a delicate essay in Impressionism, reminiscent of the snow landscapes of Camille Pissarro.

Plate 5 *Self-portrait in front of an Easel*. 1884-5. 25⅝ × 21⅛ in. (65 × 54.5 cm.). Collection Dr Jacques Körfer, Berne.
Painted during Gauguin's stay in Copenhagen. While Mette was using the drawing room to give French lessons to young members of the nobility, Gauguin had to take refuge in a small attic bedroom which was lit by a narrow fanlight. He had only himself as a model and stayed there alone during the long months of winter, painting his own portrait. This picture, obviously painted looking into a mirror, is a direct and objective study of his appearance; it is the work of a powerful temperament, the expression of his firm resolve to succeed as a painter.

Plate 6 *Mandolin and Flowers*. 1885. 24 × 20 in. (61 × 51 cm.). Louvre, Paris.
A carefully formalised arrangement which shows the influence of Cézanne, particularly in the simplification of the shapes and the firm, precise outlines. Part of one of Gauguin's landscapes appears on the wall behind. Gauguin was very fond of playing the mandolin and the guitar.

Plate 7 *The Beach at Dieppe*. 1885. 28⅛ × 28⅛ in. (71.5 × 71.5 cm.). Carlsberg Glyptotek, Copenhagen.
Painted during his brief visit to Dieppe in the autumn of 1885.

Plate 8 *The White Tablecloth (Pension Gloanec)*. 1886. Oil on panel. 21¾ × 23 in. (55 × 58.5 cm.). Collection The Hon. Michael Astor, London.
The inscription shows that this was painted in the Pension Gloanec during his first visit to Pont-Aven. Though Impressionist in its study of light, shadows and reflections it also reveals the influence of Cézanne, notably in the inclined perspective of the table top and the introduction of flowered wallpapers as a background.

Plate 9 *Martinique Landscape*. 1887. 44½ × 33½ in. (113 × 85 cm.). National Gallery of Scotland, Edinburgh.
The pictures executed on Martinique marked a move away from Impressionism towards a form of decoration. In this

splendid landscape, Gauguin has used flat patches of colour to create a rich decorative pattern, like a tapestry.

Plate 10 *Young Breton Bathers*. 1888. 36⅛ × 28½ in. (91.5 × 72.5 cm.). Kunsthalle, Hamburg.
Gauguin executed several paintings of bathers at Pont-Aven in June-July 1888. 'They are not at all like Degas... completely Japanese, by a savage of Peru'.

Plate 11 *Woman with a Jug*. 1888. 36¼ × 28¼ in. (92 × 72 cm.). Private Collection, Paris.
Painted at Pont-Aven. Though he has not yet broken completely with the Impressionist vision, Gauguin is trying here to create a pattern by means of simplified areas of contrasting colours, somewhat after the manner of Japanese prints. There is a discrepancy between the linear, simplified treatment of the figure and the more Impressionistic background.

Plate 12 *The Vision after the Sermon*. 1888. 28¾ × 36¼ in. (73 × 92 cm.). National Gallery of Scotland, Edinburgh.
Also known as *Jacob wrestling with the Angel*. This picture, painted after seeing Bernard's *Breton Women in a Field*, is discussed at length on pages 8-9. It is the masterpiece of his Synthetist phase.

Plate 13 *Old Women of Arles*. 1888. 28¾ × 36 in. (73 × 91.5 cm.). Mr and Mrs L. L. Coburn Collection, Art Institute of Chicago.
Painted while he was staying at Arles with Van Gogh (see page 9). One of Gauguin's most stylised compositions, very much influenced by Japanese prints. A path with a bench appears in the top left and a pond with goldfish on the right. The background is seen in steep perspective; flat planes of colour create a strong decorative pattern. All figures have been placed to one side of the picture.

Plate 14 *The Schuffenecker Family*. 1889. 28¾ × 36¼ in. (73 × 92 cm.). Louvre, Paris.
Painted early in 1889, while he was staying with the Schuffeneckers after his return from Arles. Theo Van Gogh wrote to Vincent on 19 January 1889: 'He is still temporarily at the Schuffeneckers and is going to do the portrait of the whole family'. Gauguin's friend and biographer Rotonchamp refers to a version inscribed 'Je vote pour Boulangg... [Boulanger]'. The pictures on the wall are a still-life by Gauguin and a Japanese print from his collection.

Plate 15 *La Belle Angèle*. 1889. 36¼ × 28½ in. (92 × 72 cm.). Louvre, Paris.
A portrait of Angèle Satre painted at Pont-Aven. M. and Mme Satre, who lived next door to the Pension Gloanec, were friends of Gauguin who painted this picture for them as a present. He considered it his most successful portrait to date, but the sitter herself took fright at its rough vigour and stylisation and declined to accept it. It was included in his auction in 1891, when it was bought by Degas.
The picture is divided asymmetrically into two parts, each with its own space. The object on the left is a Peruvian idol.

Plate 16 *The Yellow Christ*. 1889. 36¼ × 29 in. (92 × 73.5 cm.). Albright-Knox Art Gallery, Buffalo (Charles Clifton, James G. Forsyth, Elizabeth H. Gates, Charles W. Goodyear, Edmund Hayes and Sherman S. Jewett Funds).
Begun at Pont-Aven and finished after Gauguin's final move to Le Pouldu. The Christ was based on a wooden, polychromed crucifix in the chapel of Trémalo, near Pont-Aven. The village of Pont-Aven and the Colline Sainte-Marguerite appear in the background.
A little later, probably in December 1889, Gauguin painted a self-portrait with the upper part of *The Yellow Christ* on the wall behind his head (the pose in reverse, seen looking into a mirror).

Plate 17 *The Breton Calvary*. 1889. 36¼ × 29 in. (92 × 73.5 cm.). Musées Royaux des Beaux-Arts, Brussels.
Also known as *The Green Christ*. Painted at Le Pouldu; probably inspired by the Romanesque calvary at Nizon.

Plate 18 *Self-portrait with a Halo*. 1889. Oil on panel. 31¼ × 20¼ in. (79.5 × 51.5 cm.). National Gallery of Art, Washington, D.C. (Chester Dale Collection).
Painted on the righthand door of a massive cupboard at Le Pouldu (see page 14). A companion picture of Meyer de Haan as the devil was painted on the left-hand door.

Plate 19 *Still-life dedicated to the Comtesse de N(imal)*. 1889. 19⅜ × 21½ in. (49 × 54.5 cm.). Collection Mrs Terence Kennedy, East Grinstead.

In the autumn of 1889 Gauguin met the Comtesse de Nimal and her daughter in Marie Henry's inn at Le Pouldu and succeeded in interesting them in his work. The Comtesse boasted of her friendship with Rouvier, the Finance Minister, and promised Gauguin that she would get the State to buy his wood relief *Soyez amoureuses* and obtain a good position for him in Tonking. Gauguin dedicated this still-life to her; but in the end all her promises came to nothing.

A strong influence of Japanese prints. Some flattening of the picture space, a bizarre cutting of the forms by the edges of the picture, a decentralised composition.

Plate 20 *Bonjour Monsieur Gauguin*. 1889. 36½ × 29 in. (113 × 92 cm.). National Gallery, Prague.

This is not the painting which was stuck on the upper panel of the door opening into the hall at Le Pouldu (see page 14) but an enlarged and improved version.

The title was inspired, somewhat ironically, by Courbet's *Bonjour Monsieur Courbet* which Gauguin had seen in the museum at Montpellier in December 1888. With grim humour, Gauguin has made himself appear seedy, lonely and miserable – a rather alarming apparition. There is an effect of light breaking through storm clouds.

Plate 21 *Harvest: Le Pouldu*. 1890. 28¾ × 36¼ in. (73 × 92 cm.). Tate Gallery, London.

Gauguin and Bernard painted a number of Breton harvest scenes in 1889 and 1890. The forms are rhythmically stylised; some of the shapes have a marked Art Nouveau character.

Plate 22 *Marie Derrien*. 1890. 25⅝ × 21½ in. (65 × 54.5 cm.). Joseph Winterbotham Collection, Art Institute, Chicago.

Formerly regarded as a portrait of Marie Henry, though it is not very much like her; the sitter actually seems to have been Marie Derrien, whose nickname was Marie 'Lagadu', meaning in Breton dialect, 'Black Eyes'. The painting in the background (considerably exaggerated in size) is the still-life by Cézanne from Gauguin's collection, a picture which he particularly prized. The treatment of the figure

recalls some of Cézanne's portraits of Mme Cézanne in its simplification, firm modelling and rhythmical design.

Plate 23 *The Loss of Virginity*. 1890-1. 35 × 52 in. (89 × 132 cm.). Walter P. Chrysler, Jr. Collection, New York.

Rotonchamp records that this picture was painted in Paris in the winter of 1890-1 as a result of Gauguin's close association with the Symbolist writers. 'In the execution of this picture Gauguin was much less concerned with pictorial considerations than with putting into practice certain literary theories which are incompatible with painting'. A virgin is seized by the demon of physical desire, as represented by a fox, an Indian symbol of lasciviousness. In the distance, a Breton wedding procession makes its way along a narrow path. Bold saturated colours, but a lack of unity between figure and setting.

The landscape background was abstracted from *Harvest: Le Pouldu* (plate 21). As model for the girl, Gauguin used his mistress, Juliette Huet, who bore him a daughter some months after his departure for Tahiti.

Plate 24 *Vahine no te Tiare* (Woman with a Flower). 1891. 27¾ × 18¼ in. (70.5 × 46.5 cm.). Carlsberg Glyptotek, Copenhagen.

Painted within a few months of his arrival in Tahiti. Gauguin relates in *Noa Noa* that he had wanted for a long time to paint the portrait of this woman, who was one of his neighbours, of pure Tahitian extraction. At last he invited her into his hut to see his photographs of paintings and, while she was looking at them, attempted surreptitiously to make a sketch of her. She noticed this, made a face and disappeared... only to appear again an hour later, wearing a fine dress, with a flower in her hair. 'I worked in haste – being afraid that she might change her mind – in haste and with passion'. It was the first of his Tahitian pictures to be seen in France.

Plate 25 *Two Women on a Beach*. 1891. 27 × 35½ in. (69 × 90 cm.) Louvre, Paris.

Two Tahitian women squatting on a beach (one of them plaiting a leaf hat); the sea in the background. A more or less straightforward representation of the appearance of his

models, without any poetic or mystical overtones. Though the figures are given their full weight and volume, the tipped perspective of the beach and the areas of contrasting colours create a decorative pattern.

A later variant of this composition, inscribed 'Parau api' (News) and dated 1892, is in the Gemäldegalerie, Dresden.

Plate 26 *I raro te Oviri* (Under the Pandanus Palms). 1891. 29 × 36 in. (74 × 91.5 cm.). Minneapolis Institute of Arts, William H. Dunwoody Fund.
The figures are based on sketches in Gauguin's Tahitian sketchbook; the composition is more stylised and imaginative than *Two Women on a Beach* (plate 25). Brilliant, unreal colours convey an impression of the blazing tropical light, while the sinuous lines in the foreground are used both structurally and to create a rhythmical pattern.

Another version of *I raro te Oviri*, also dated 1891, is in the Dallas Museum of Contemporary Art.

Plate 27 *Ta Matete* (The Market). 1892. 29½ × 36¼ in. (75 × 92 cm.). Kunstmuseum, Basel.
The girls on the bench are probably prostitutes who were said to frequent the market at Papeete. Their attitudes, heads and feet in profile, with stiff, conventionalised gestures, were derived from Egyptian art. The forms are arranged in a series of planes parallel to the picture surface, like the wings on a stage.

Plate 28 *Parau Parau* (Conversation). 1892. 30 × 37¾ in. (76 × 96 cm.). Collection Mr and Mrs John Hay Whitney, New York.
A scene of everyday life in Tahiti. The attitude of the girl on the left was derived from Javanese sculpture, the circle of seated women from *Les Parau Parau* (Hermitage, Leningrad), a painting made by Gauguin the previous year.

Plate 29 *Tahitian Mountains. c.* 1893. 26¾ × 36⅜ in. (68 × 92.5 cm.). Minneapolis Institute of Arts, Julius C. Eliel Memorial Fund.
Writing in *Noa Noa* of his first attempt at painting in Tahiti, Gauguin declared: 'The landscape, with its bold, intense colours, dazzled and blinded me'. This picture, closer to nature than *I raro te Oviri*, was probably painted in 1893.

Plate 30 *Nafea Faaipoipo* (When are you to be married?). 1892. 41¼ × 30½ in. (105 × 77.5 cm.). Kunstmuseum, Basel.
Gauguin wrote to Mette in May 1892: 'I am hard at work, now that I know the soil and its odour, and the Tahitians whom I represent in a very enigmatic manner are none the less Maoris and not Orientals of the Battignoles [a part of Paris]. It has taken me almost a year to understand this'.

Plate 31 *Hina Tefatou* (The Moon and the Earth). 1893. 45 × 24½ in. (112.5 × 61 cm.). Museum of Modern Art, New York, Lillie P. Bliss Collection.
This depicts the legendary dialogue between the moon goddess Hina and the earth genie Fatou, and illustrates Gauguin's growing interest in Tahitian mythology and religion. The dialogue concerned the Eternity of Matter, in which Fatou stood for mortality and Hina for permanence.

Plate 32 *Mahana no Atua* (The Day of God). 1894. 26 × 34¼ in. (66 × 91 cm.). Art Institute of Chicago, Helen Birch Bartlett Memorial Collection.
During his stay in France between the two visits to Tahiti, Gauguin made several pictures of Tahitian subjects, as well as series of woodcuts. He had already made up his mind to return to Tahiti and his thoughts were preoccupied with the writing of *Noa Noa*. This picture embodies his idealised conception of life in Tahiti before the arrival of the Europeans.

The idol of the god Ta'aroa (Creator of the Universe) was partly inspired by Indian art; there were no idols of this type or size in Tahiti. The trees in the upper left were apparently derived from the pandanus palms in plate 26.

Plate 33 *Le Moulin David* (The David Mill). 1894. 28¾ × 36¼ in. (73 × 92 cm.). Louvre, Paris.
The Moulin David at Pont-Aven, with the Colline Sainte-Marguerite in the background. Gauguin painted only a small number of pictures of Brittany in 1894 and they differ

from his earlier Breton pictures in having a markedly exotic character.

Plate 34 *Te Arii Vahine* (The Female Chief). 1896. 38¼ × 51¼ in. (97 × 130 cm.). Pushkin Museum, Moscow.
Also known as *Woman with Mangoes*. Gauguin made a sketch of this picture in a letter to Monfreid of April 1896 and described it as follows: 'I have just made a picture of 130 cm. by 1 metre which I think is even better than anything else to date: a naked queen lying on a green carpet, a servant picking fruit, two old men, near the big tree, discussing the tree of knowledge; a beach in the background... I think that in colour I have never before made anything of such a majestic deep sonority. The trees are in flower, the dog is on guard, the two doves on the right are cooing'.

The model for this picture was his fourteen-year-old *vahine* Pau'ura. Her pose was partly based on that of Manet's *Olympia*, of which Gauguin had once made a copy.

Plate 35 *Nave Nave Mahana* (Days of Delight). 1896. 37⅜ × 51⅛ in. (95 × 130 cm.). Musée des Beaux-Arts, Lyon.
A Tahitian idyll, the grace and dignity of the simple life close to nature. Statuesque figures set between trees at different intervals in depth forming a complex but harmonious relationship; every section of the picture plays its part in the design. The viewpoint is that of the spectator on the ground. In place of the well-defined areas of contrasting colours found in most of the works of 1889-91, there is now a more unified tone and each picture has its particular colour key.

The influence of the idylls of Puvis de Chavannes is apparent here, especially in the complex rhythmical design. But whereas Puvis depicted a Neo-Classical world remote from life, Gauguin's Arcadia was founded on his own experience, and hence has a warm and living quality.

Plate 36 *No te aha oe riri* (Why are you angry?). 1896. 37⅛ × 51¼ in. (95 × 129.5 cm.). Art Institute of Chicago, Mr and Mrs Martin A. Ryerson Collection.
The composition is unusually spacious for Gauguin. Verticals and horizontals lend measure and dignity to the scene; the scale is set by the human figure.

Plate 37 *Portrait of the Artist* (*at Golgotha*). 1896. 29⅞ × 25⅛ in. (76 × 64 cm.). Sao Paulo Museum of Art.
Inscribed 'Près du Golgotha'. Probably painted in the latter part of the year, when he was passing through a period of ill-health and profound depression. As in several pictures executed in Brittany in 1889 he has portrayed himself as Christ, accentuating the resemblance by means of a tunic; two weird heads are introduced in the background.

Gauguin, who followed Renan in denying the divinity of Christ, was nevertheless very much interested in parables because of the way they could be used to convey more than one meaning.

Plate 38 *Nevermore*. 1897. 23⅜ × 45⅝ in. (59 × 116 cm.). Courtauld Institute Galleries, London.
Painted in February 1897. Like the similar *Manao tupapau* (The Spirit of the Dead Watches) of 1893 (Collection Conger Goodyear, New York) this was inspired by an incident which took place during Gauguin's first visit to Tahiti.

Gauguin relates in *Noa Noa* how he returned home one night long after dark to find Teha'amana lying naked on the bed, petrified by fear of the *tupapaus*, the legendary spirits of the dead who were said to walk by night. Between her sobs she exclaimed: 'Never again leave me alone like this without a light'.

In describing the picture to Daniel de Monfreid, Gauguin wrote: 'I wanted by means of a simple nude to suggest a certain barbaric luxury of ancient times. The whole is drowned in colours which are deliberately sombre and sad... For title, *Nevermore*; not the raven of Edgar Allen Poe, but the bird of the devil that is keeping watch'.

This painting, which Gauguin considered especially successful, was bought from Monfreid in 1898 by the composer Frederick Delius for 500 francs.

Plate 39 *Te Rereioa* (The Dream). 1897. 37½ × 51¼ in. (95 × 130 cm.). Courtauld Institute Galleries, London.
Painted in March 1897, immediately after *Nevermore*. 'Te Rereioa', he told Monfreid, 'that is the title. Everything is dream-like in this picture; is it the child, is it the mother, is it the horseman on the track or better still is it

the dream of the painter!!! All that has nothing to do with painting, people will say. Perhaps, but perhaps not'.

The composition may have been partly inspired by Delacroix's famous picture *Algerian Women*, in which there are two squatting women similarly disposed in the corner of a room.

Plate 40 *D'Où Venons Nous? Que Sommes Nous? Où Allons Nous?* (Whence do we come? What are we? Where are we going?). 1897. 54¾ × 147½ in. (139 × 274.5 cm.). Museum of Fine Arts, Boston.
Gauguin painted this picture before attempting suicide at the end of December 1897. 'I wanted before dying to paint a large picture which I had in mind, and for the whole month I worked at it day and night in an incredible fever. Lord knows it isn't a painting done like a Puvis de Chavannes, studies from nature, then preparatory cartoon, etc. It was painted without a model, straight from the brush, on a sackcloth canvas full of knots and wrinkles, so its appearance is terribly rough.

'People will say that it is careless... unfinished. It is true it is difficult to judge one's own work, but nevertheless I believe that this canvas not only surpasses in value all the previous ones, but that I shall never make a better or a similar one. I have put into it before dying all my energy, a passion so painful in terrible circumstances, and a vision so clear, needing no corrections, that the hastiness disappears and life surges up'.

D'Où Venons Nous?, painted as his final statement, a last great picture, not only sums up and to some extent synthesises the various themes which had been preoccupying him, but makes use of actual figures and motifs drawn from earlier pictures. For example the two shadowy figures by the tree of knowledge were derived from *Te Arii Vahine* (plate 34); the old woman on the left appears in many earlier works, including *Soyez amoureuses et vous serez heureuses* of 1889 (page 20); the child eating a fruit resembles a child in *Nave Nave Mahana* (plate 35); the two squatting women who look towards us are sisters of those in *Nafea Faaipoipo* (plate 30); and the girl on the left, leaning on one hand, together with the strange bird beside her, are drawn from *Vairumati* of 1897 (Louvre).

Plate 41 *Faa Iheihe* (Decoration). 1898. 21¼ × 66¾ in. (54 × 169.5 cm.). Tate Gallery, London.
Painted about the same time as *The White Horse*, though possibly the later of the two; the horseman on the right appears in both pictures. Its format resembles that of *D'Où Venons Nous?* but unlike the latter it has no definite symbolic content. The mellow, golden colours and the references to a pastoral life amid fruit and flowers reflect Gauguin's reviving health and peace of mind.

The influence of Javanese sculptured friezes appears not only in the frieze-like conception, but in the attitude of certain figures such as the woman in the centre with the palm of her hand raised between her breasts. At the same time, there are echoes of Puvis de Chavannes and even of the Parthenon frieze.

Plate 42 *The White Horse.* 1898. 55½ × 36 in. (141 × 91 cm.). Louvre, Paris.
Probably painted in his spare time, after he had taken a job as draughtsman in the Public Works Department in Papeete. It was commissioned by one of his principal creditors, Ambroise Millaud, a local chemist, who asked him for a 'comprehensible and recognisable' picture; but when it was finished, Millaud declined to accept it.

Its sombre colours, and in particular its large areas of ultramarine, relate it to *D'Où Venons Nous?* The white horse was based on a standing horse in the Parthenon frieze, of which Gauguin had a photograph taken by Gustave Arosa.

Plate 43 *Bouquet of Flowers.* c. 1900. 37½ × 24¼ in. (90.5 × 61.5 cm.). Private Collection, Paris.
One of Gauguin's most ambitious and sumptuous still-lifes. It has sometimes been dated as early as 1891 and sometimes as late as 1901, but seems to be closest to his works of about 1900, the year in which Vollard wrote to him offering to buy flower pictures. The mask adds a note of mystery.

Plate 44 *Three Tahitians.* 1899 (?). 28 × 36¾ in. (71.5 × 93 cm.). National Gallery of Scotland, Edinburgh.
The date on this picture seems to be '99' but has sometimes been read as '97' (1897). The two outer figures appear again, full-length, against a similar background, in a com-

position called *Maternity* which exists in two versions: Hermitage, Leningrad (dated 1899) and Mr and Mrs David Rockefeller Collection, New York (undated, but probably, also 1899). This picture is slightly closer to the former. It is quite common for Gauguin to use more or less the same figures several times over in different combinations.

Plate 45 *Still-life with the Painting 'Hope' by Puvis de Chavannes.* 1901. 25¾ × 30¼ in. (65.5 × 77 cm.). Nathan Cummings Collection, Chicago.
Gauguin asked Monfreid to send him some flower seeds, and in April 1899 was able to report that most of the plants had reached maturity and were flowering marvellously. In 1901 he painted six or seven still-lifes, including four of sunflowers clearly done with van Gogh's sunflower paintings in mind. As van Gogh said: 'Gauguin... has a perfect infatuation for my sunflowers'.
The picture at the upper left is a representation of a study by Puvis de Chavannes in the Louvre, of which Gauguin had a photograph in his hut; the smaller picture is by Degas.

Plate 46 *Contes Barbares* (Barbaric Tales). 1902. 51⅛ × 36 in. (130 × 91.5 cm.). Folkwang Museum, Essen.
Like the two following works, this was painted after Gauguin's move to the Marquesas Islands. 'I am more and more pleased with my decision', Gauguin told Monfreid in November 1901, 'and I assure you that from the point of view of painting, this is *Admirable*. Models!!! a marvel... Here poetry emerges of its own accord and it is enough to let oneself dream in painting to suggest it'.
The devil-like figure on the left was based on Gauguin's portraits of Meyer de Haan made in 1889; the girl on the right was his favourite model on the Marquesas Islands, Tohotana, one of a number of red-haired natives in these islands.

Plate 47 *Riders on the Beach.* 1902. 35½ × 51¼ in. (89.5 × 130 cm.). Folkwang Museum, Essen.
Gauguin painted in 1902 two pictures of riders on the beach near Atuana; the other picture, with more figures, is in a private collection in Paris. They seem to have been inspired partly by memories of Degas's paintings of racecourse scenes.

Plate 48 *L'Appel* (The Call). 1902. 51¼ × 35½ in. (130 × 89.5 cm.). Cleveland Museum of Art, Gift of Hanna Fund and Leonard C. Hanna, Jr.
Despite his failing health, Gauguin was able, on the Marquesas Islands, to paint several masterpieces. This picture exemplifies as well as any the form of art for which he was striving: evocative content ('In painting, one must search rather for suggestion than for description, as is done in music') and extremely lyrical and 'musical' colours.

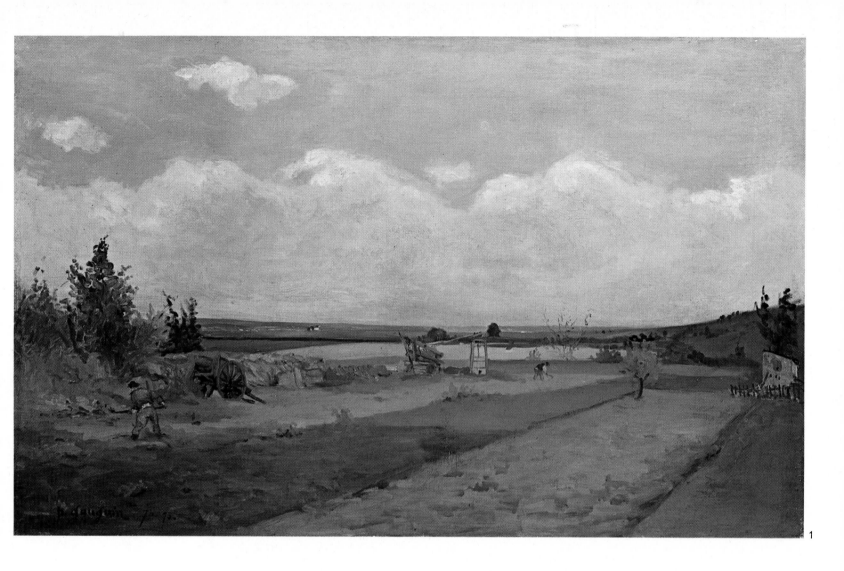

1

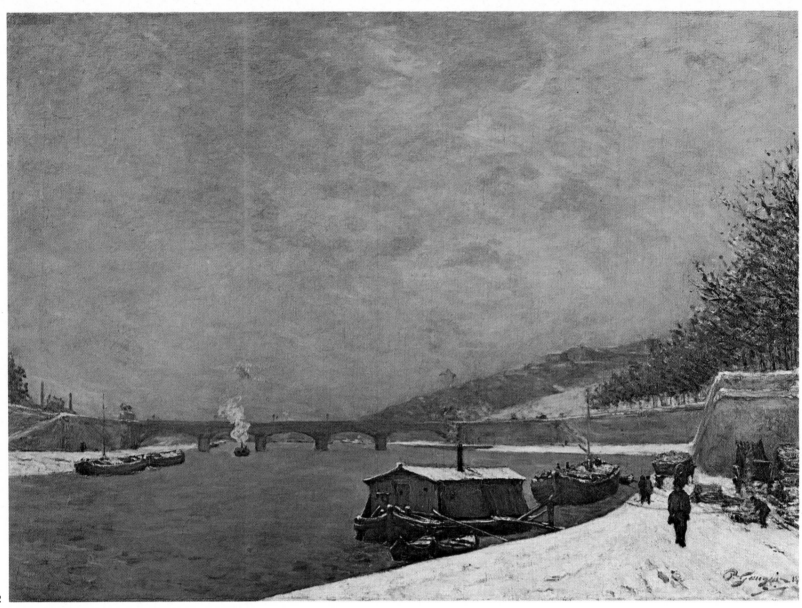

2

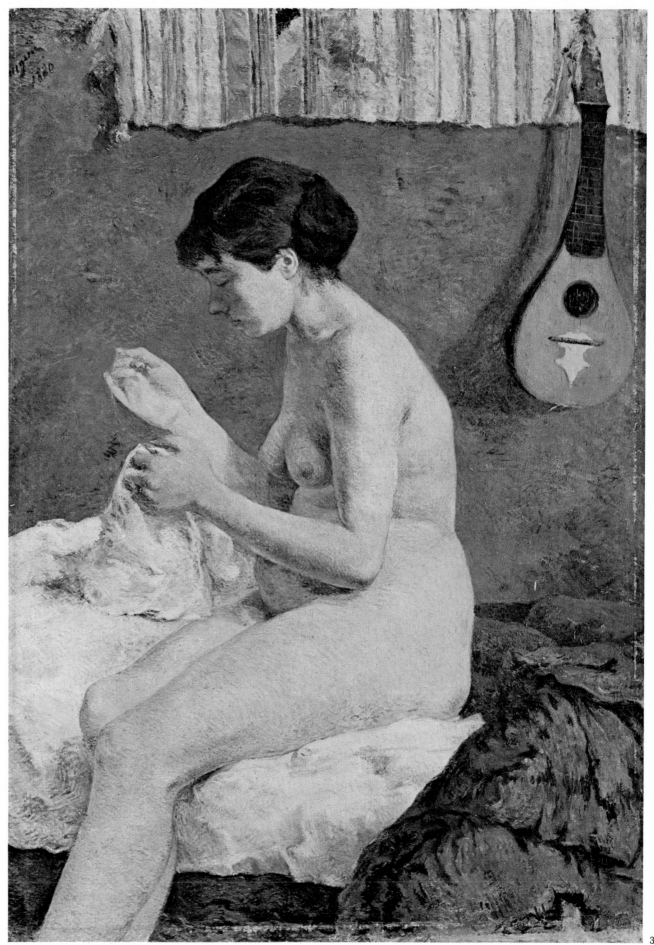

3

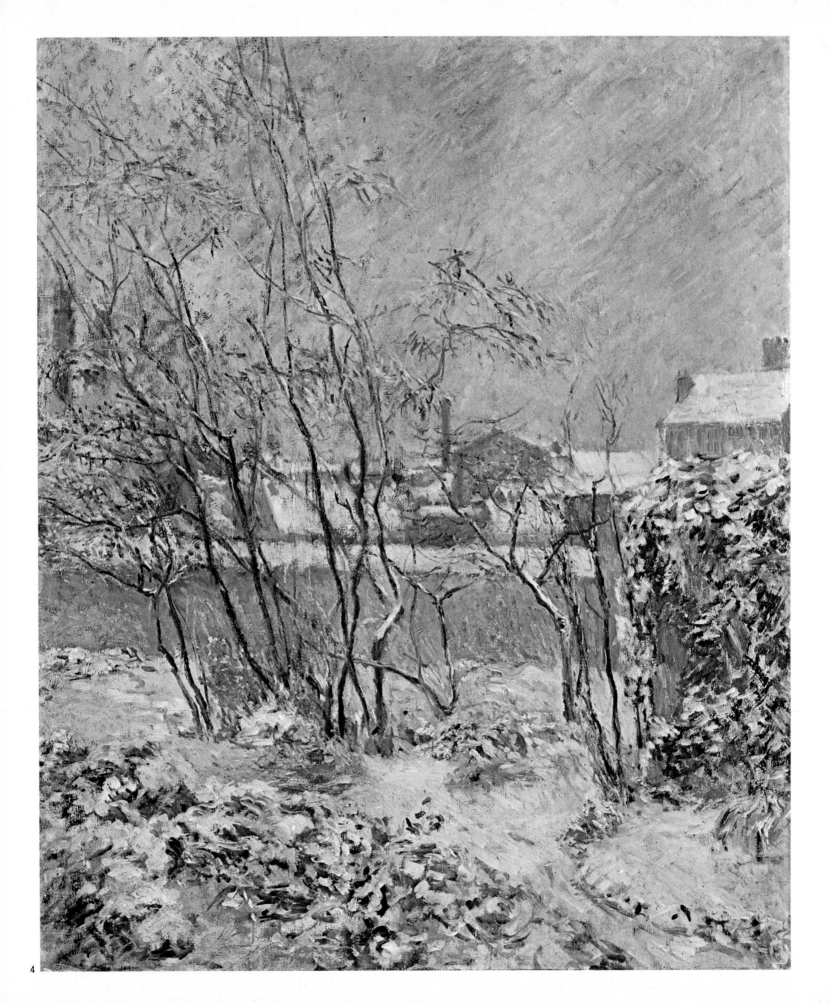

4

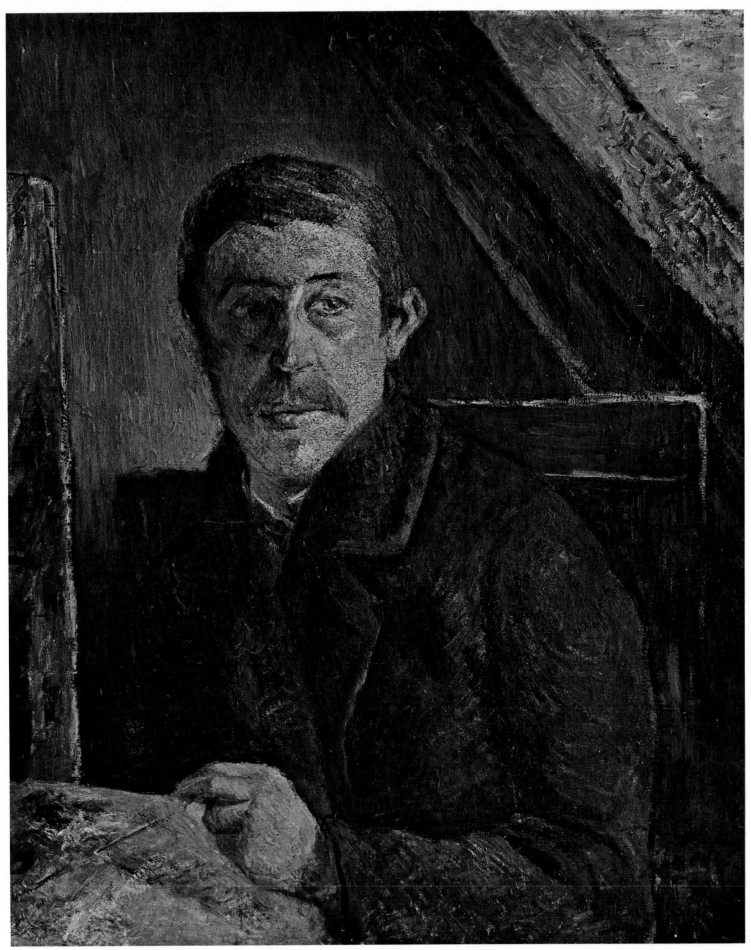

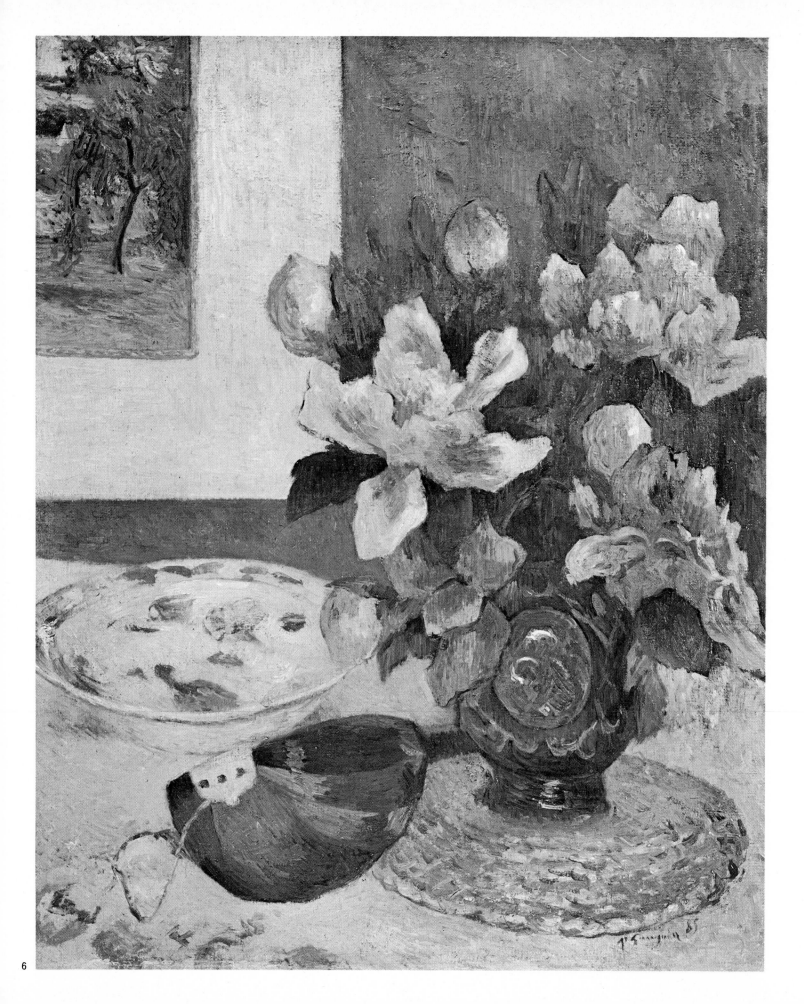

6

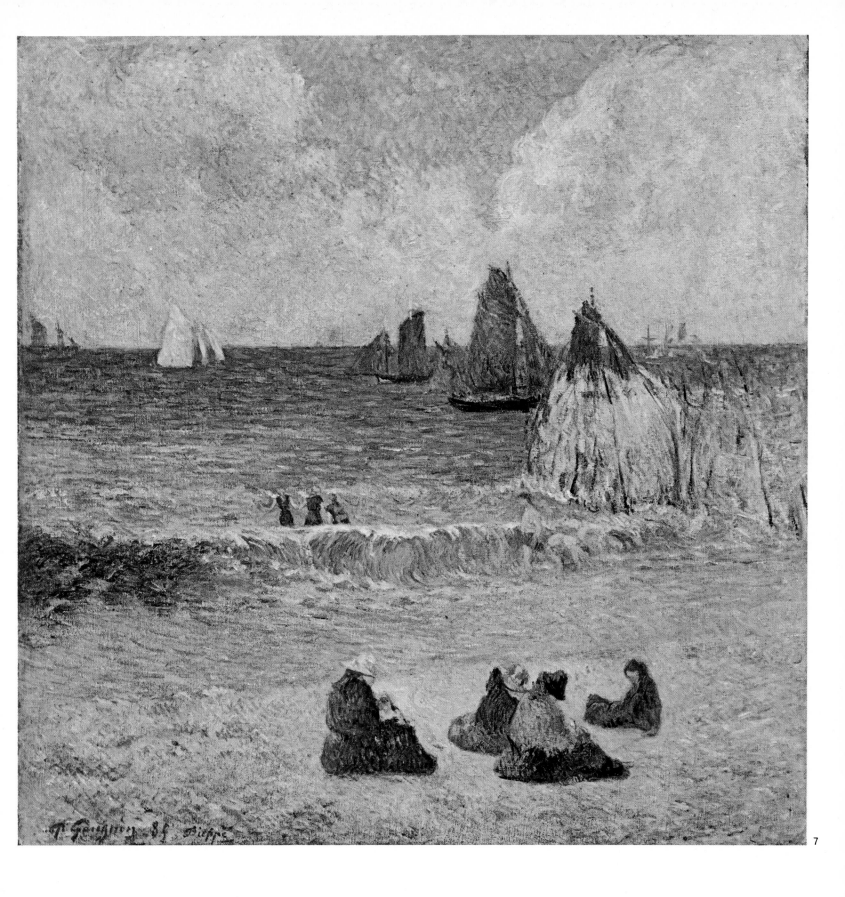

7

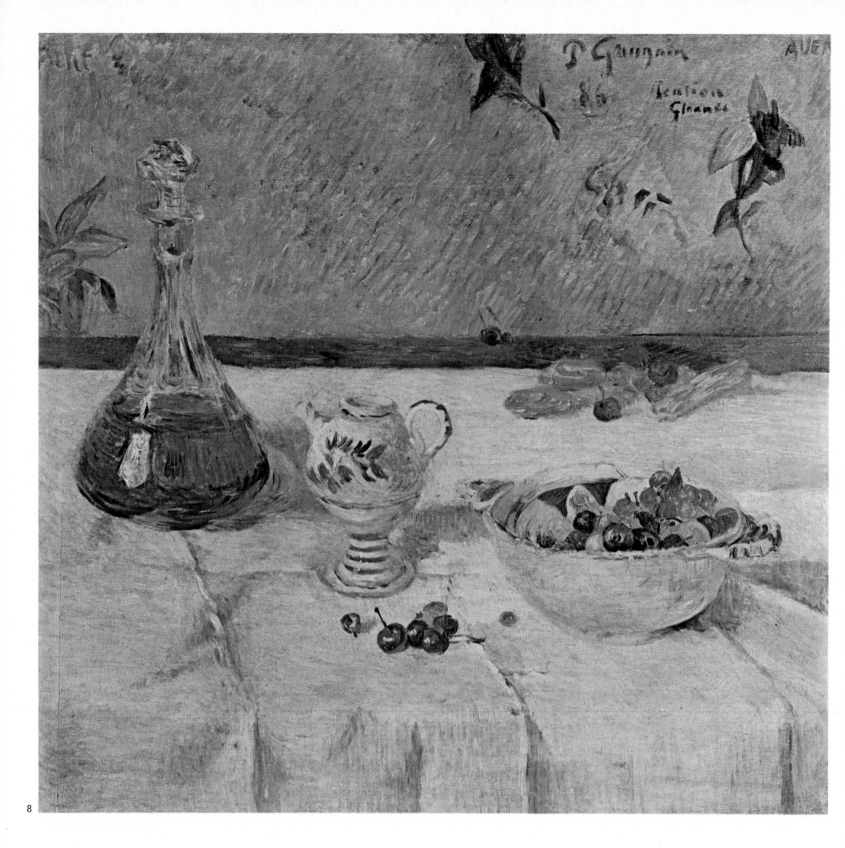

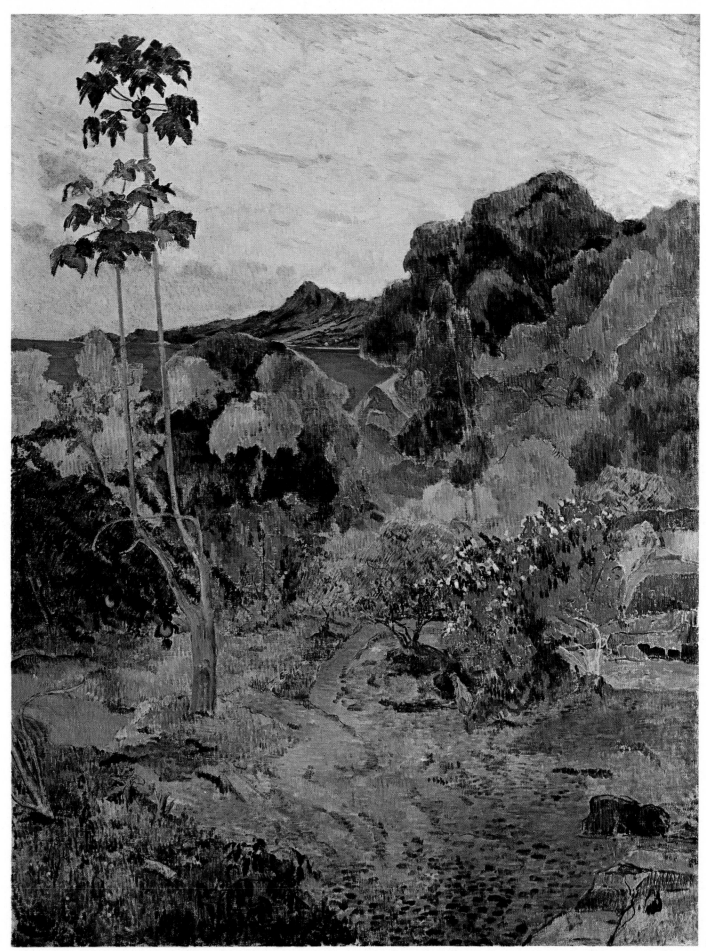

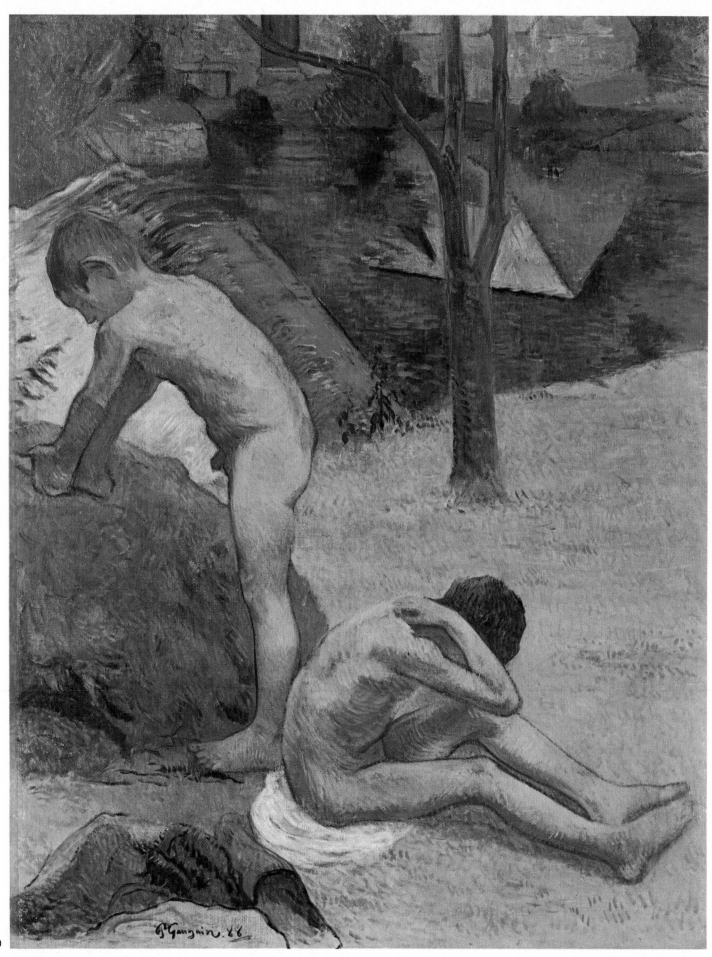

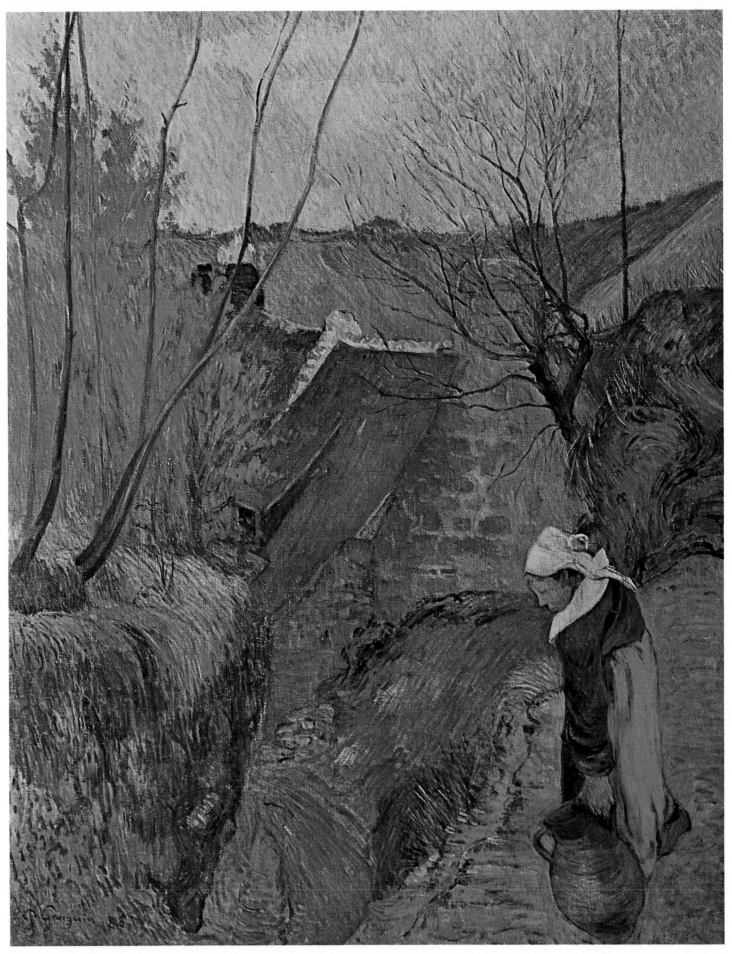

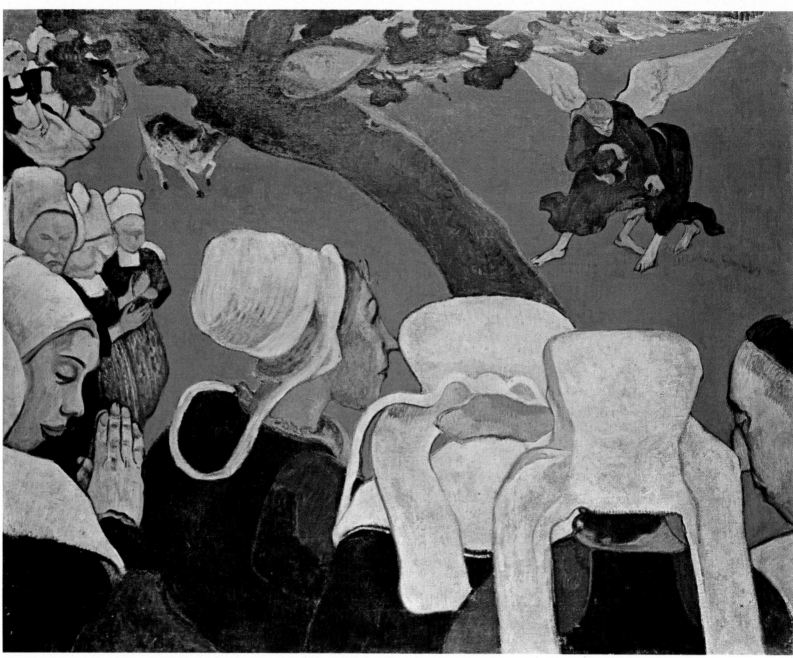

12

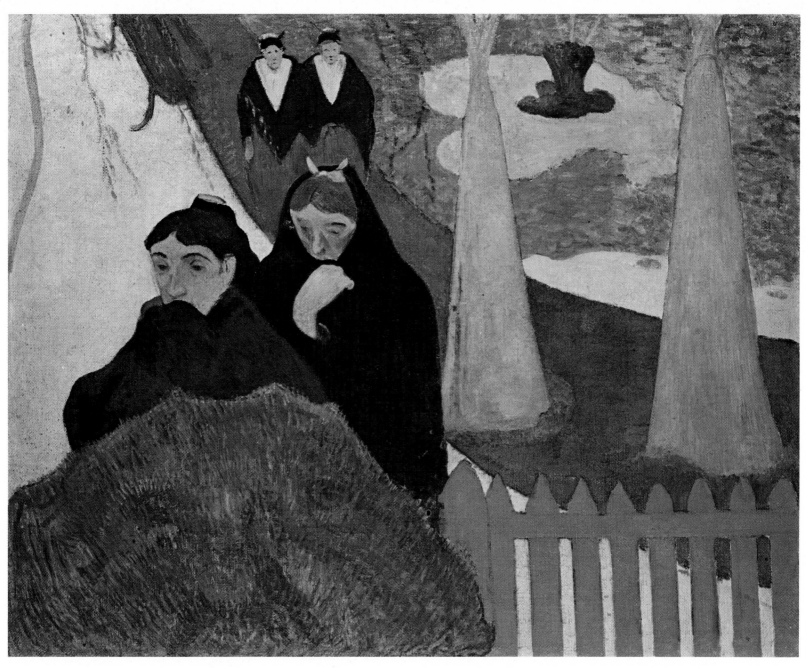

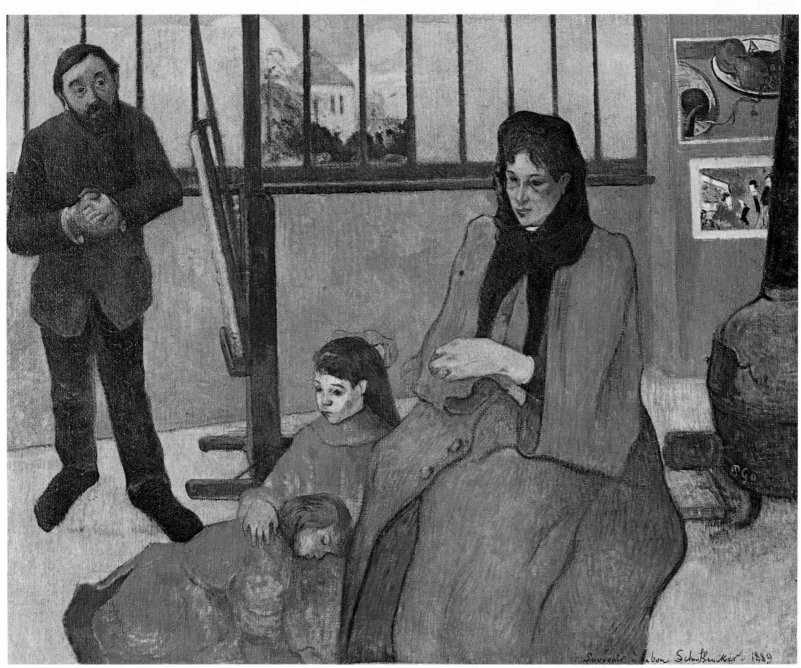

14

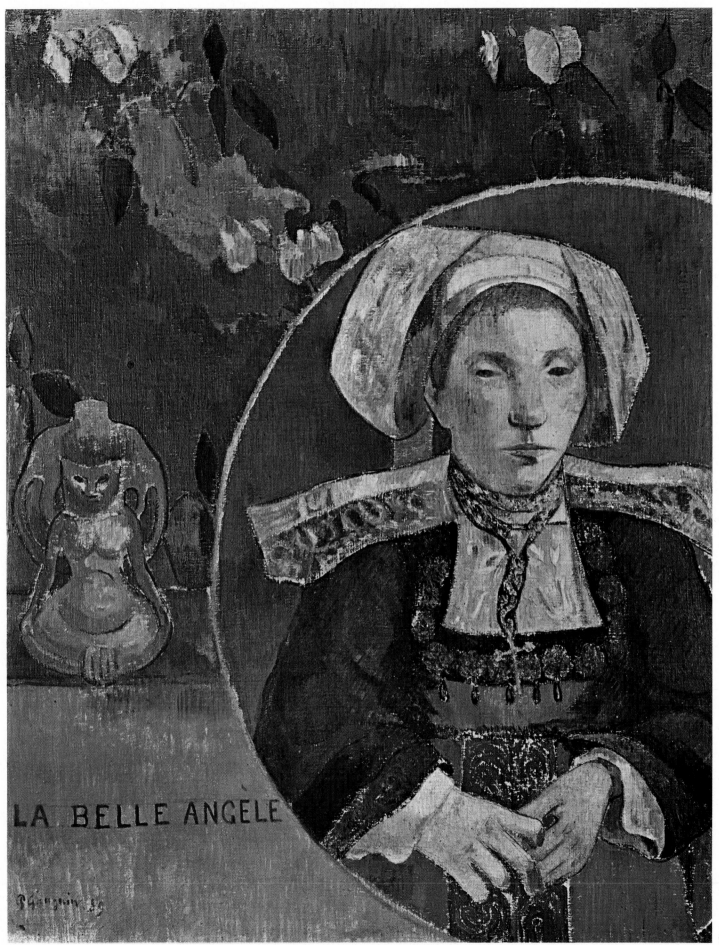

LA BELLE ANGÈLE

P.Gauguin 89

15

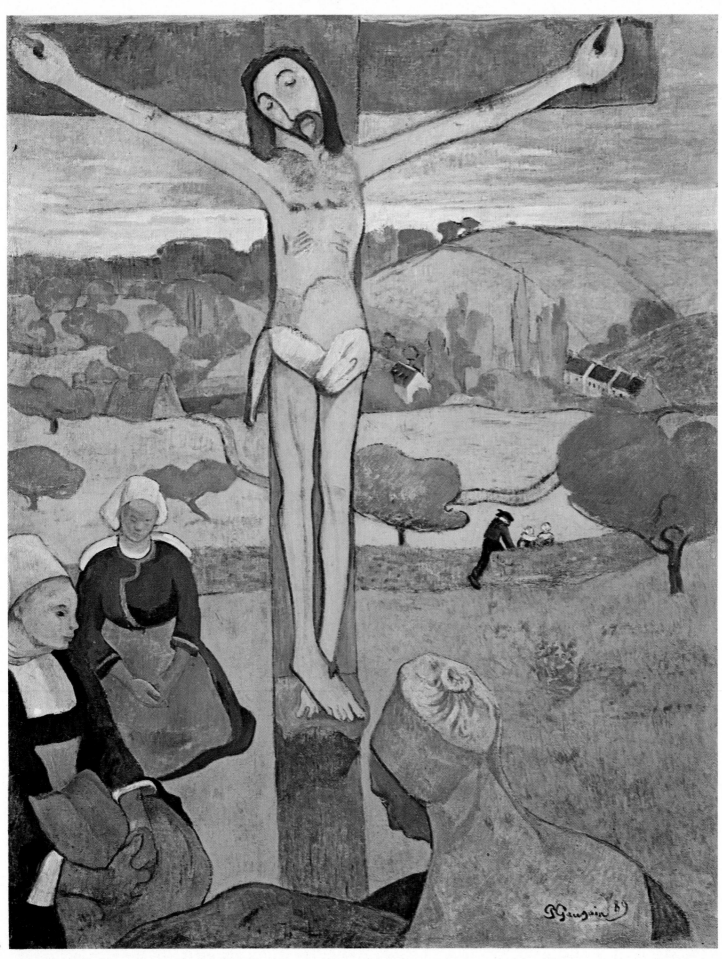

16

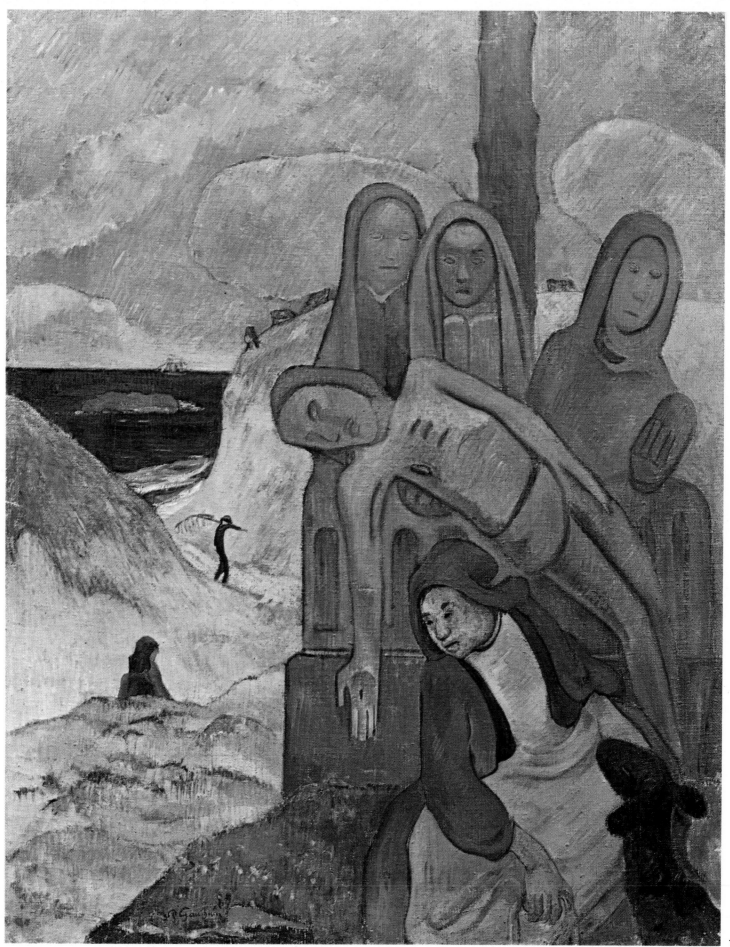

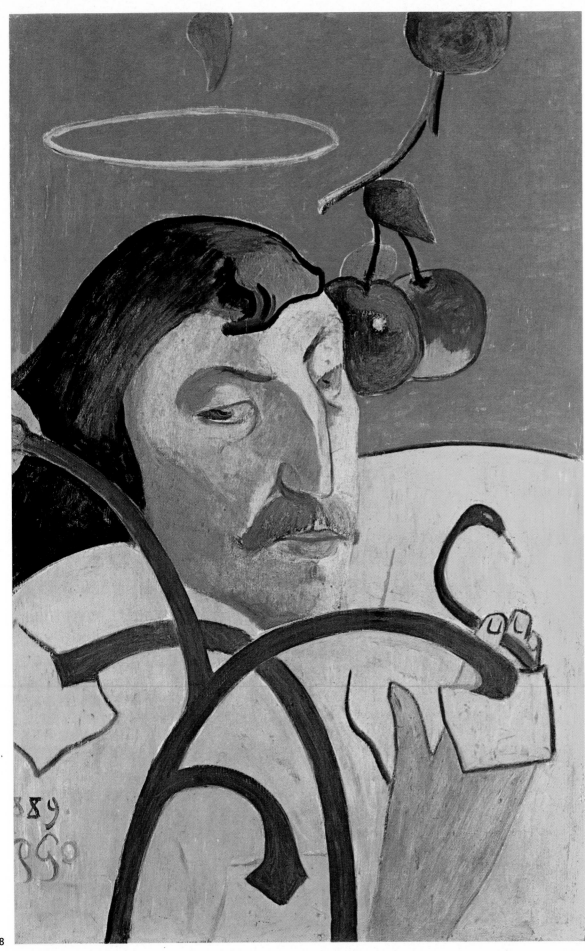

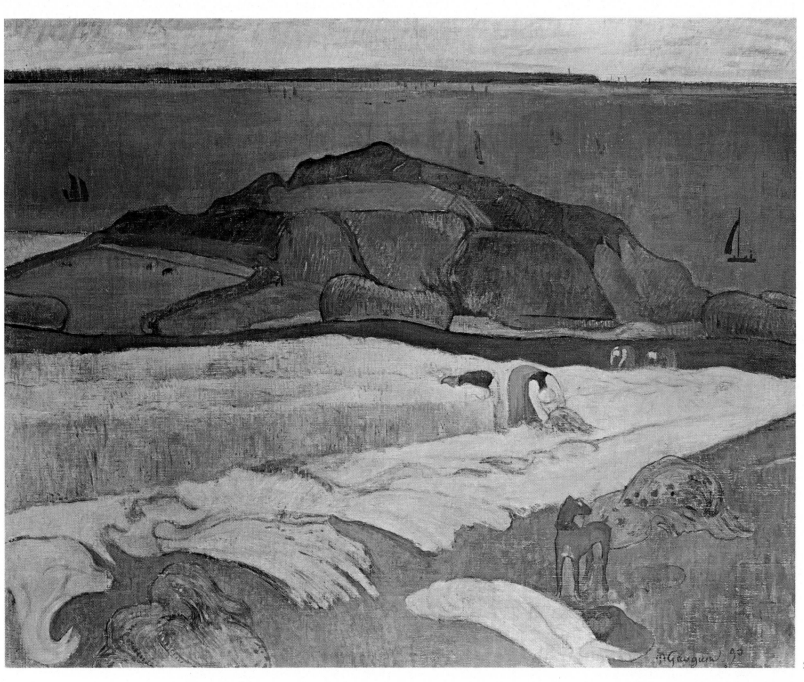

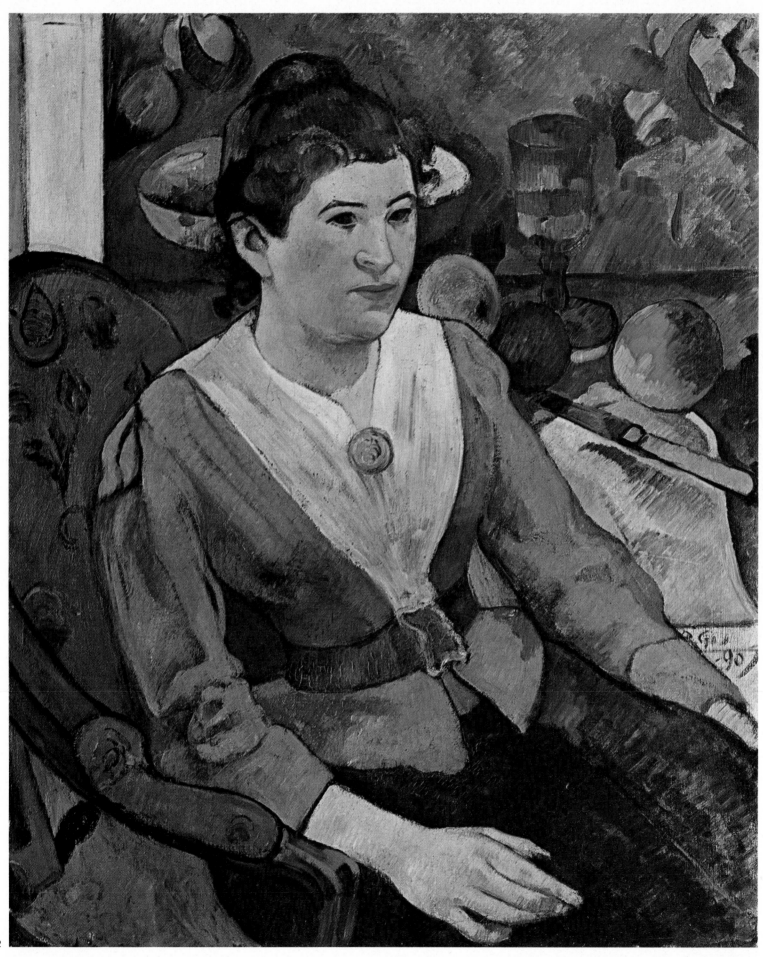

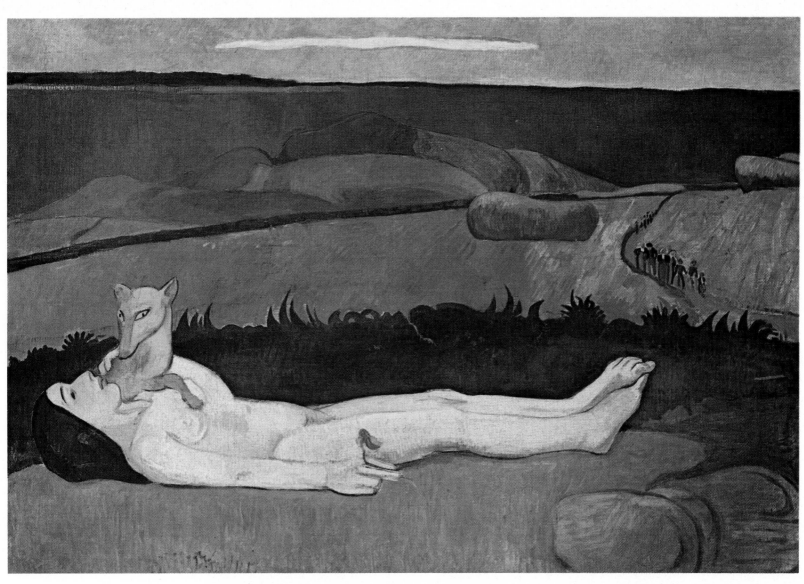

23

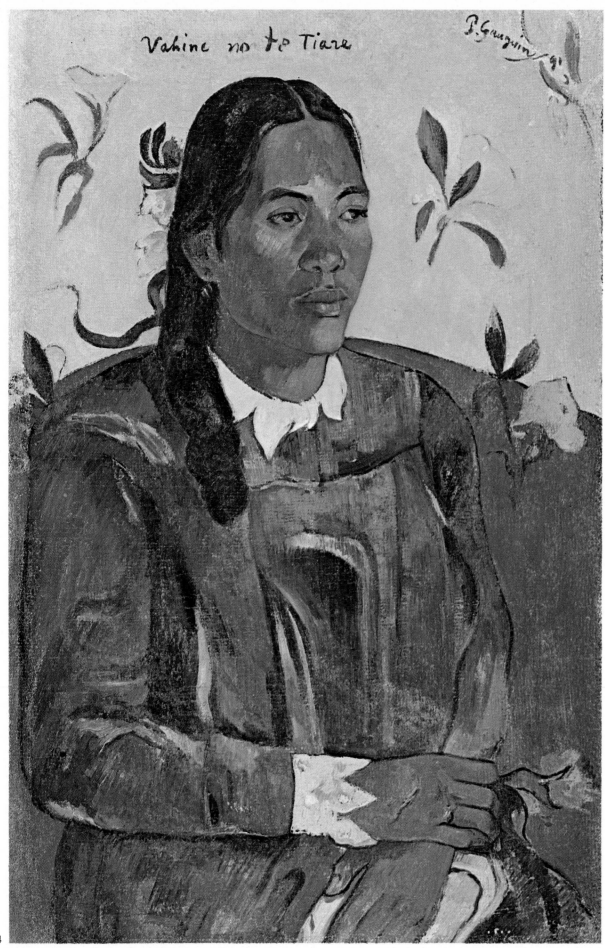

24

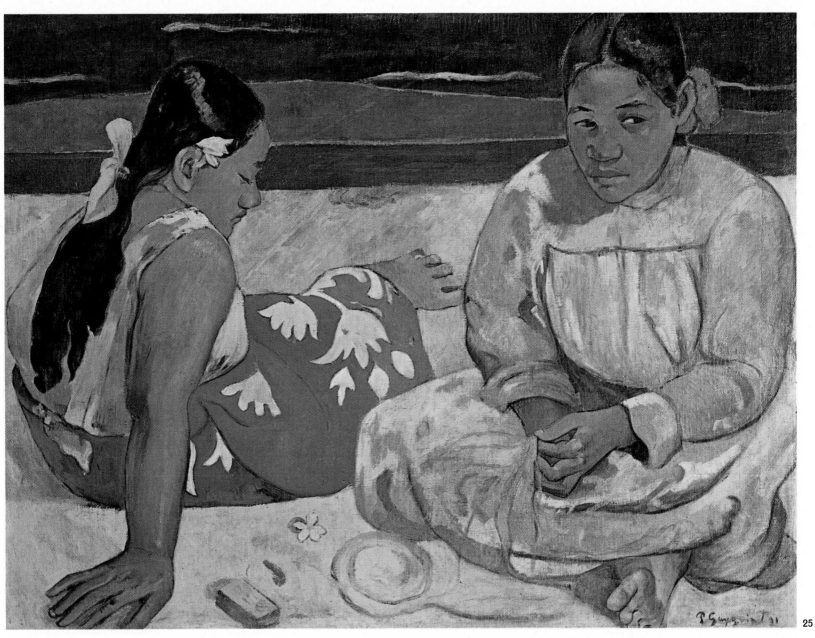

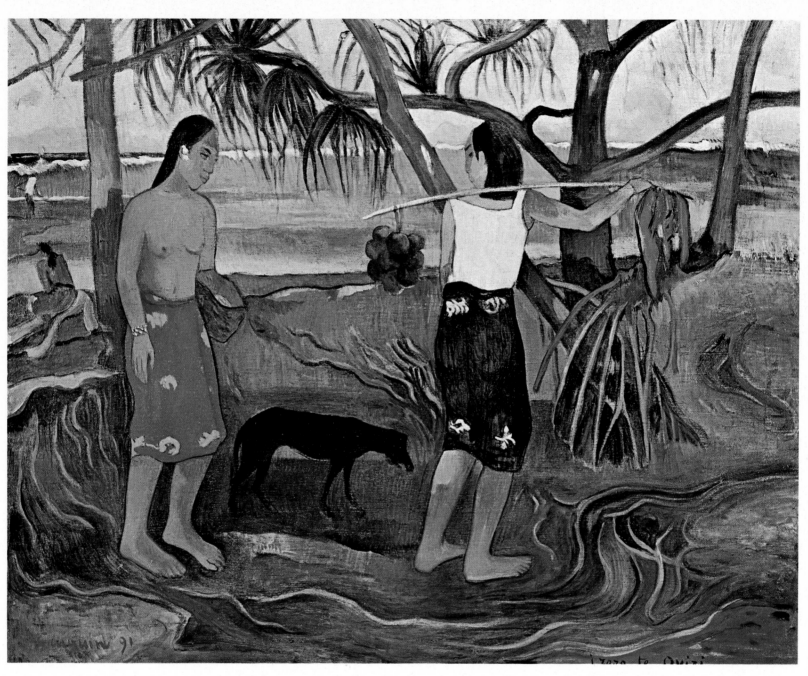

26

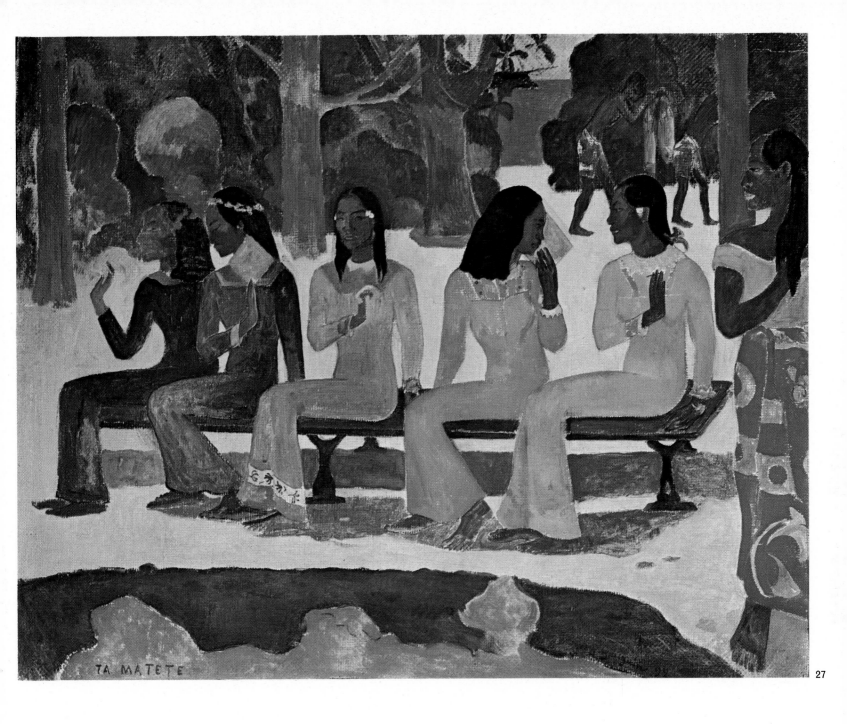

TA MATETE

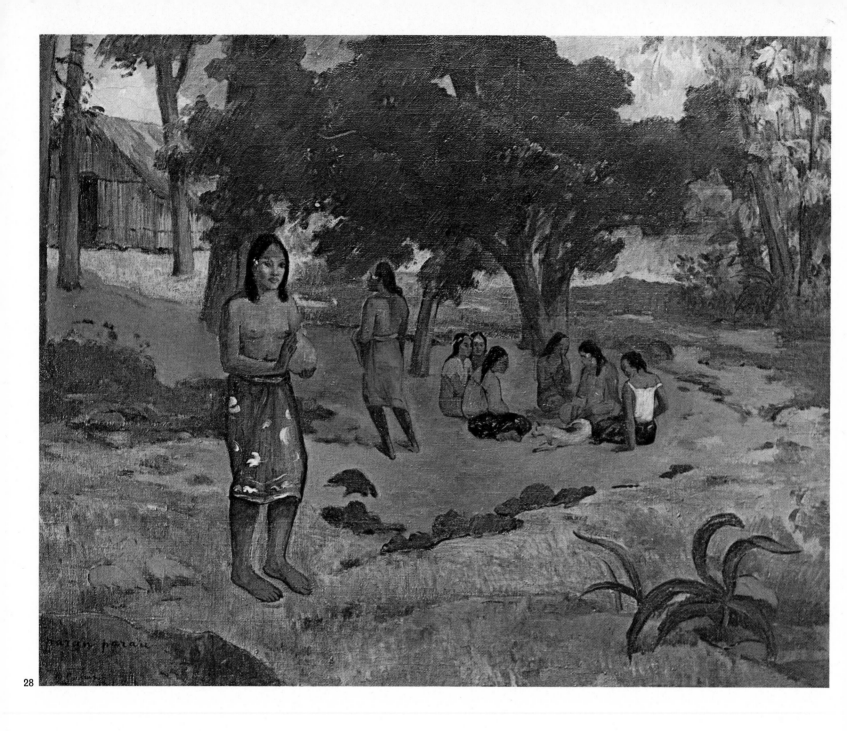

Parau parau

28

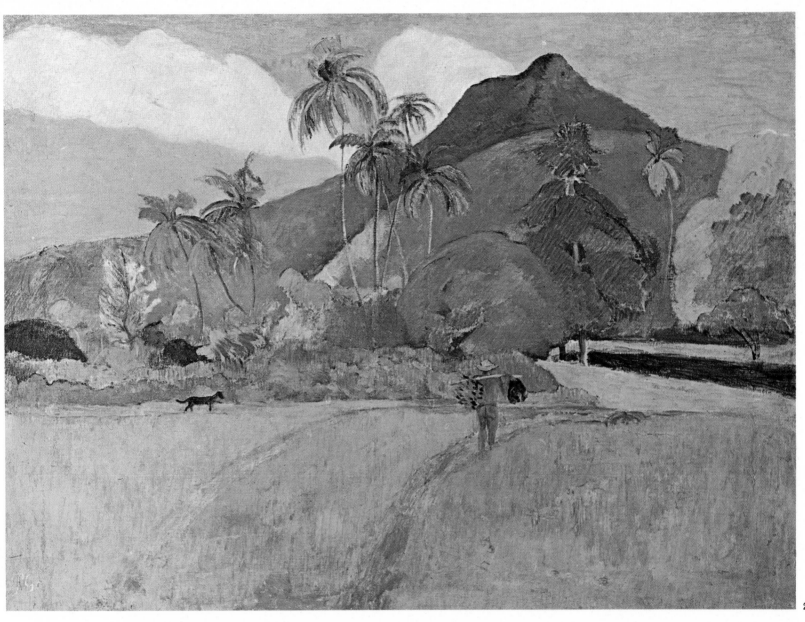

29

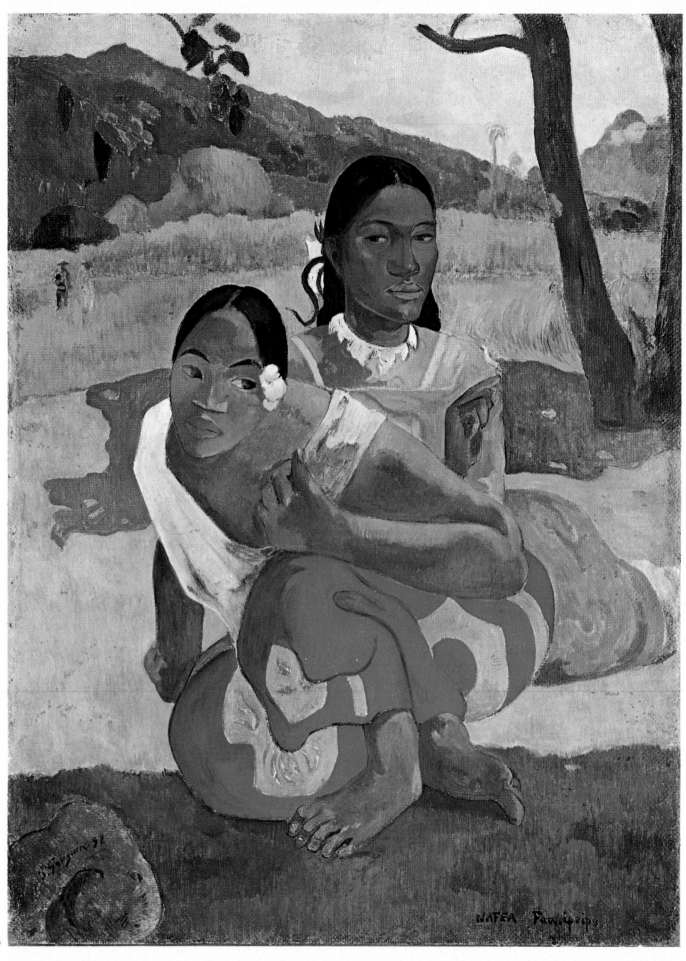

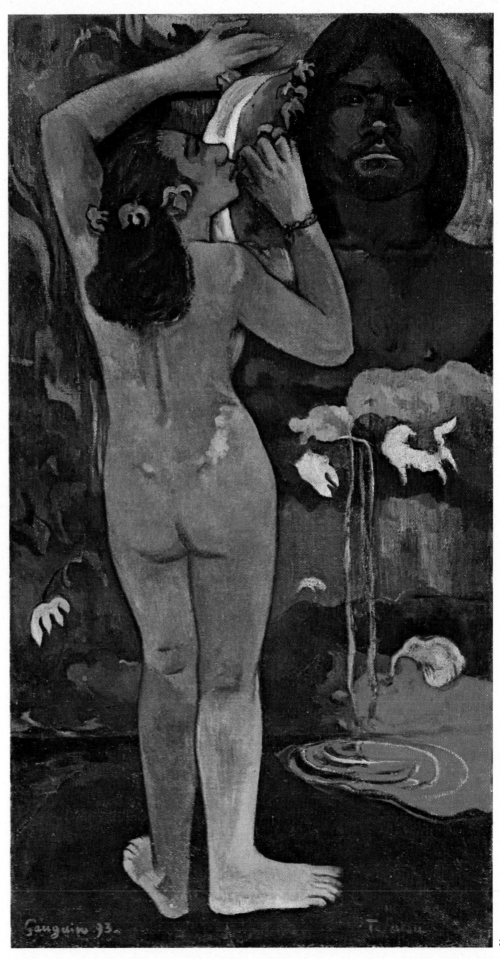

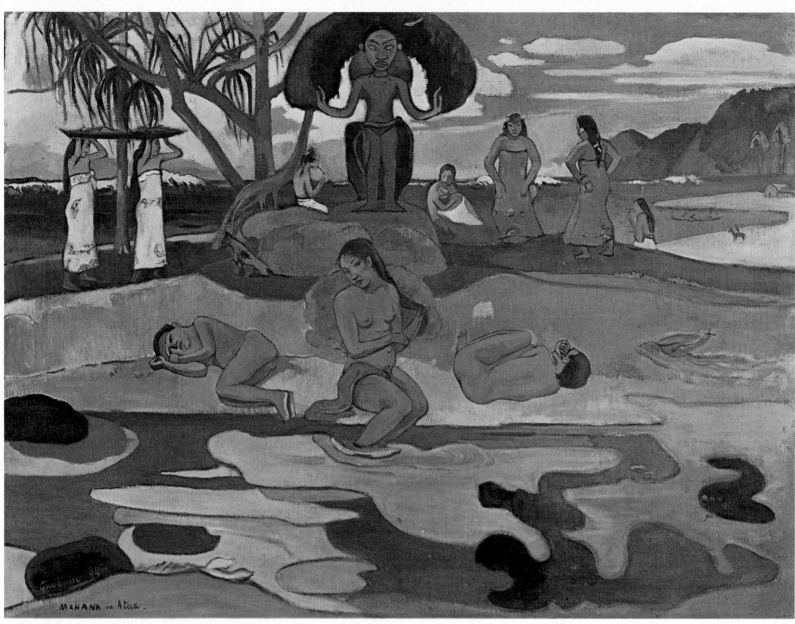

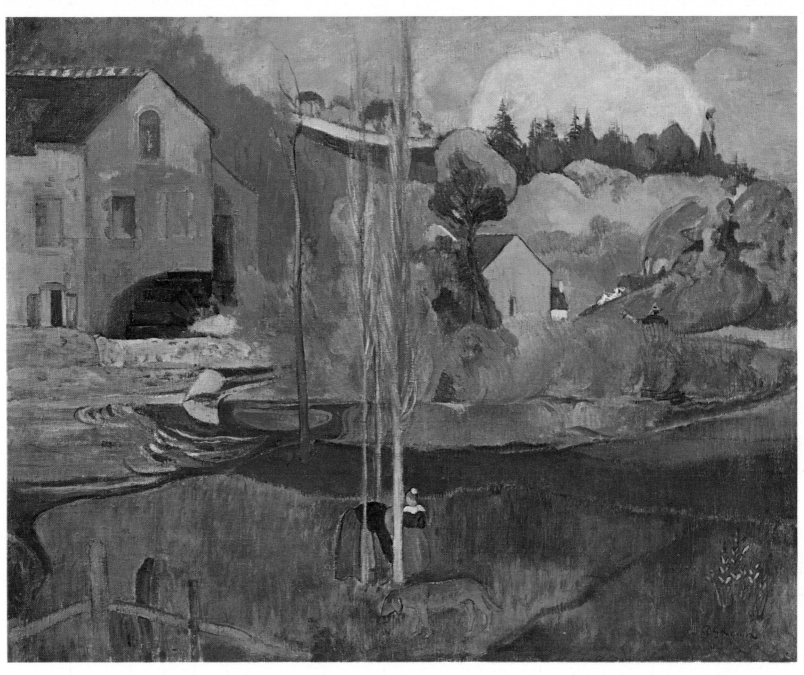

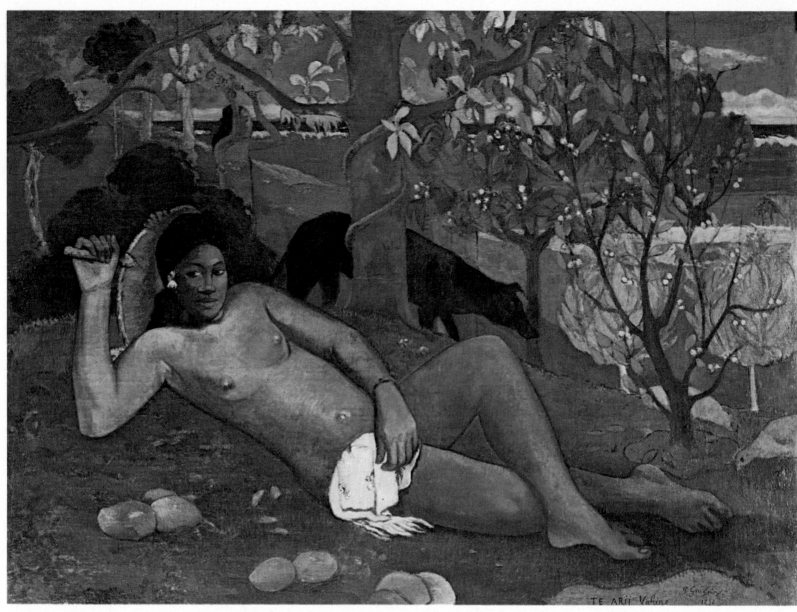

34

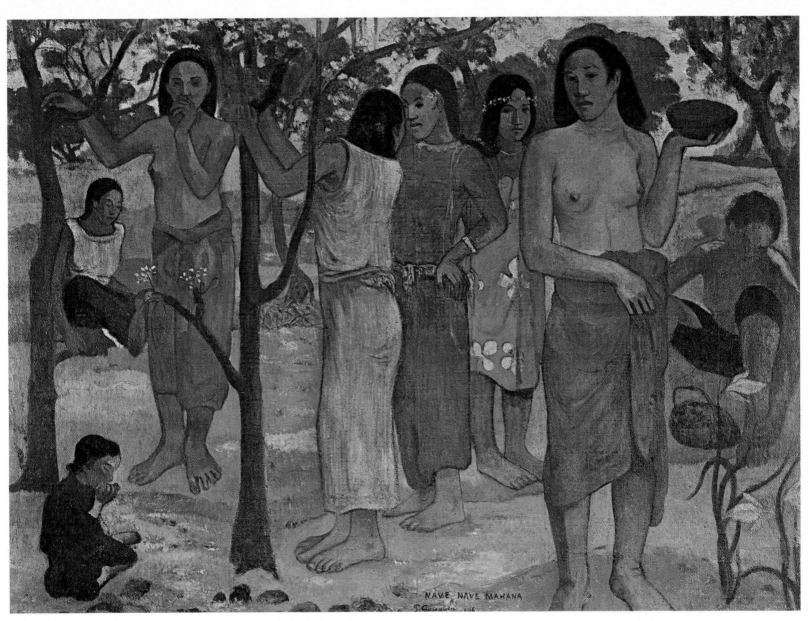

NAVE NAVE MAHANA
P. Gauguin 1896

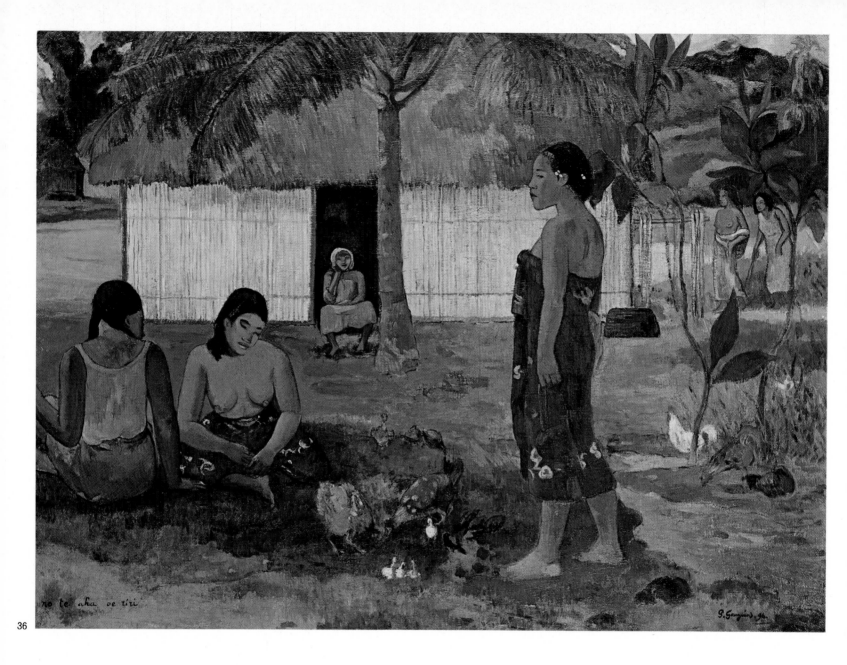

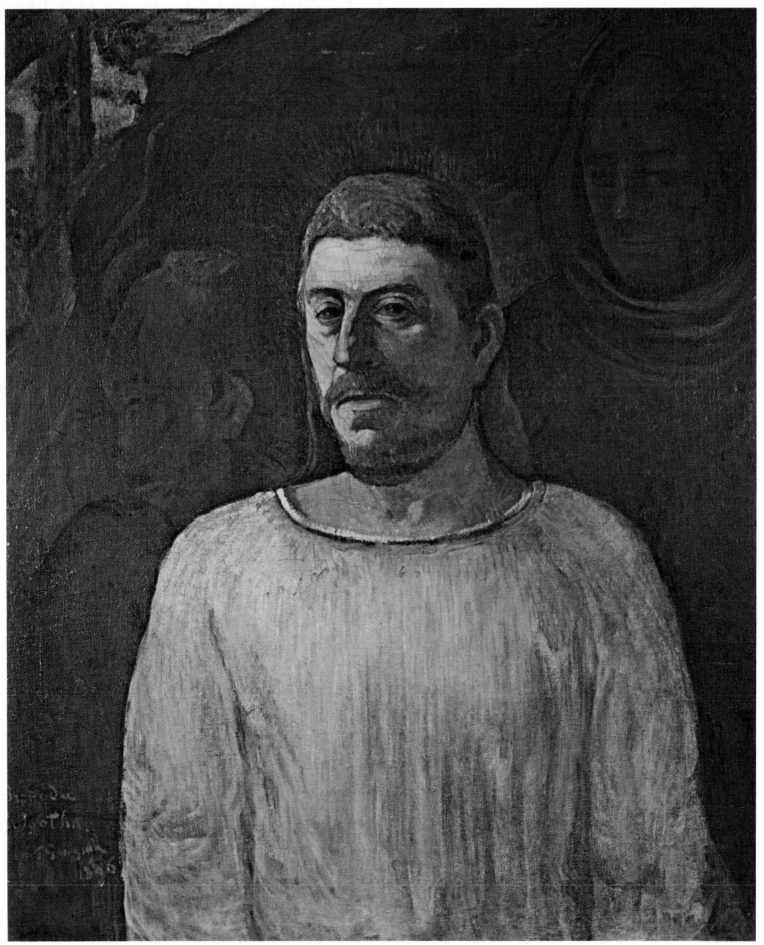

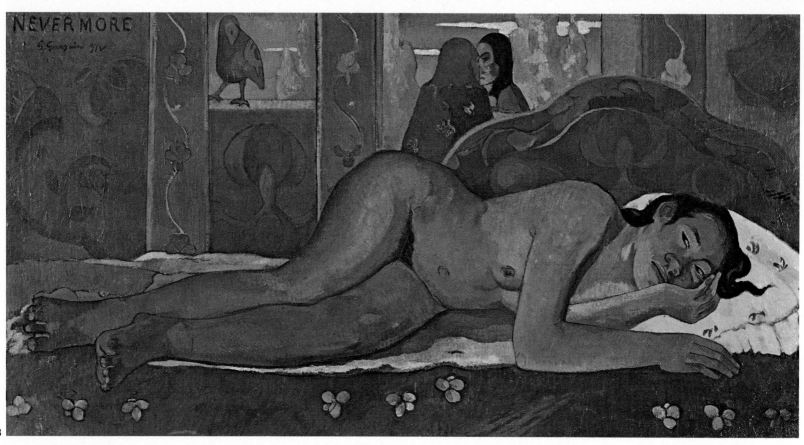

38

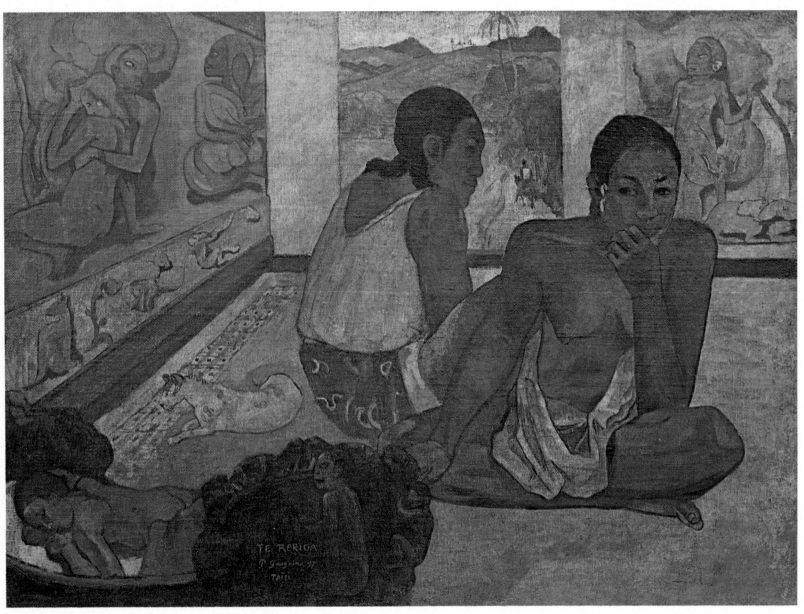

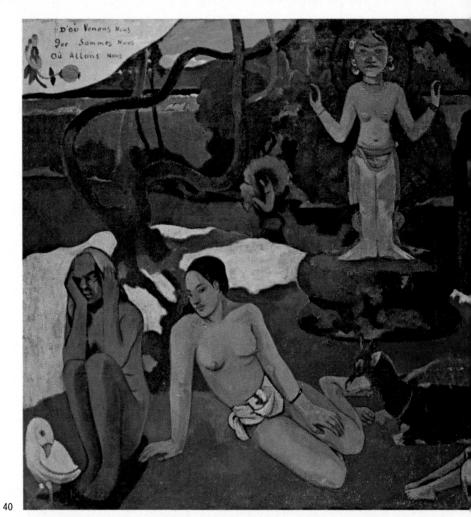

40

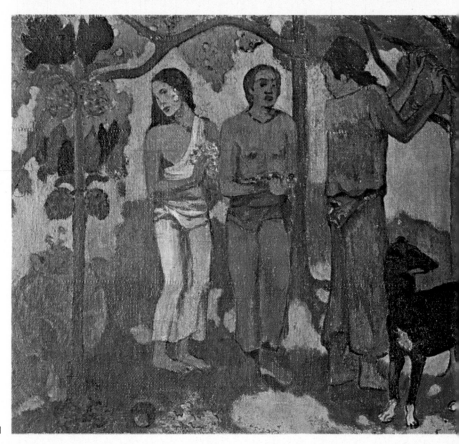

41

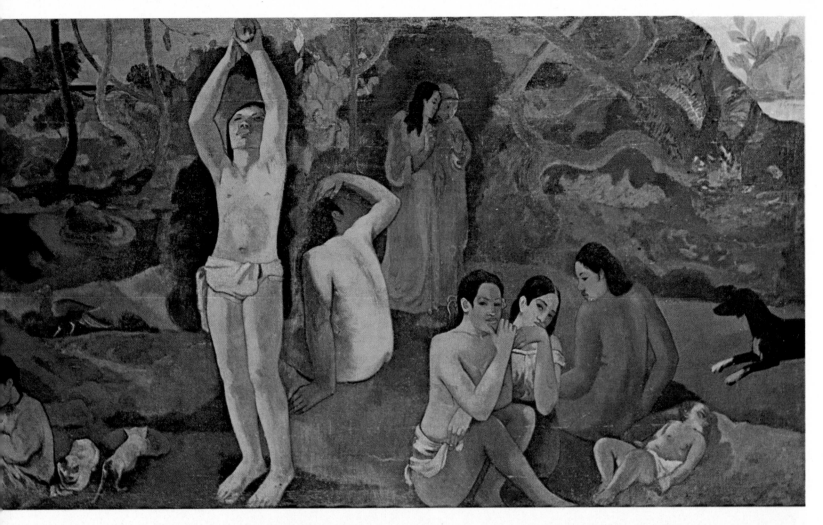

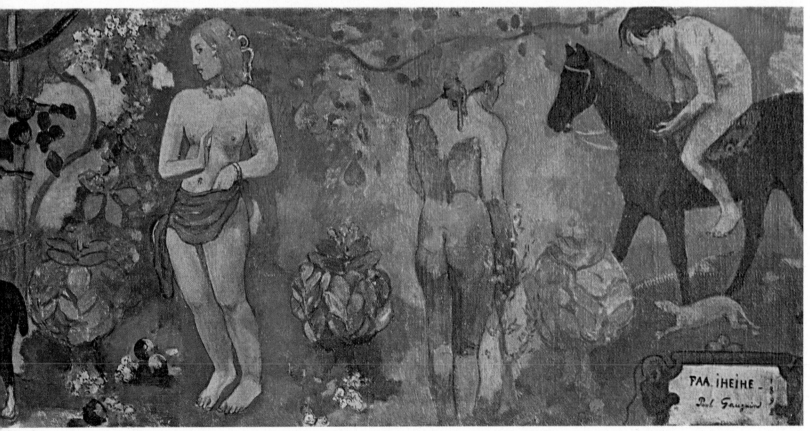

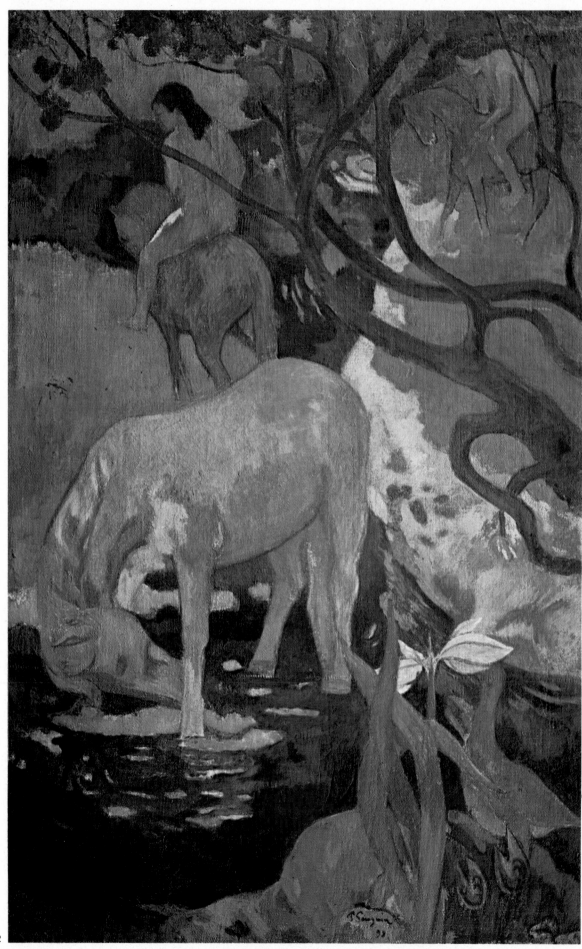

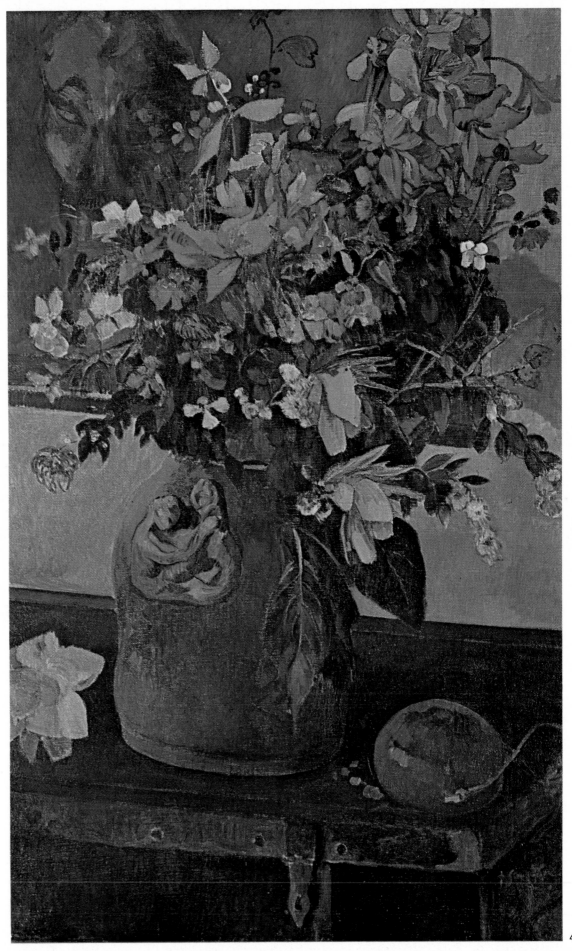

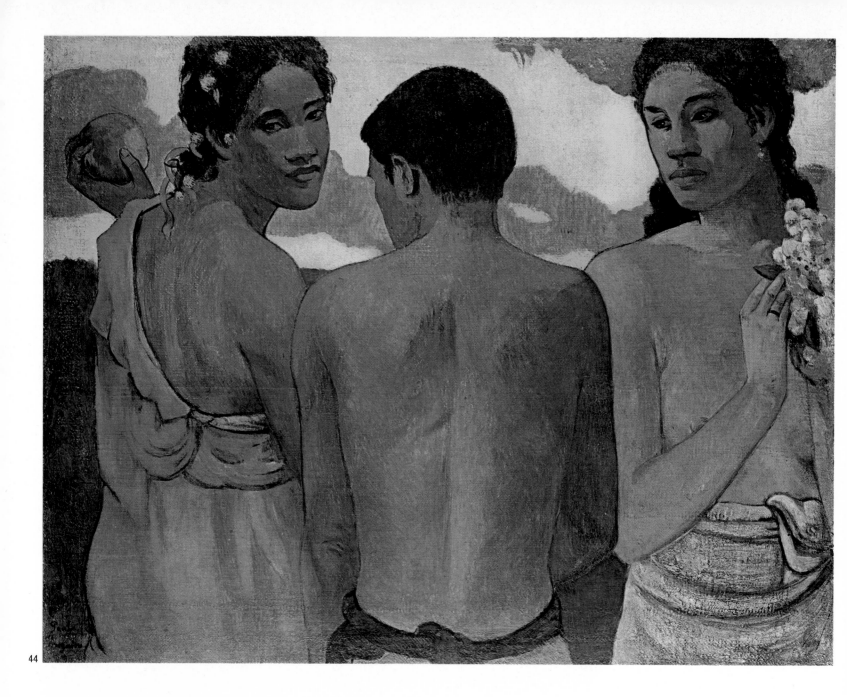

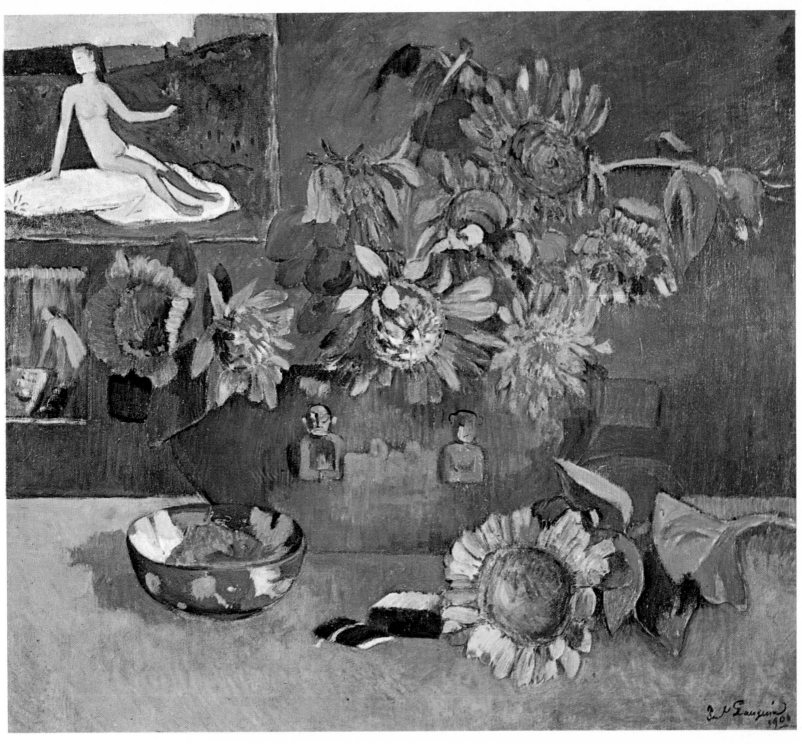

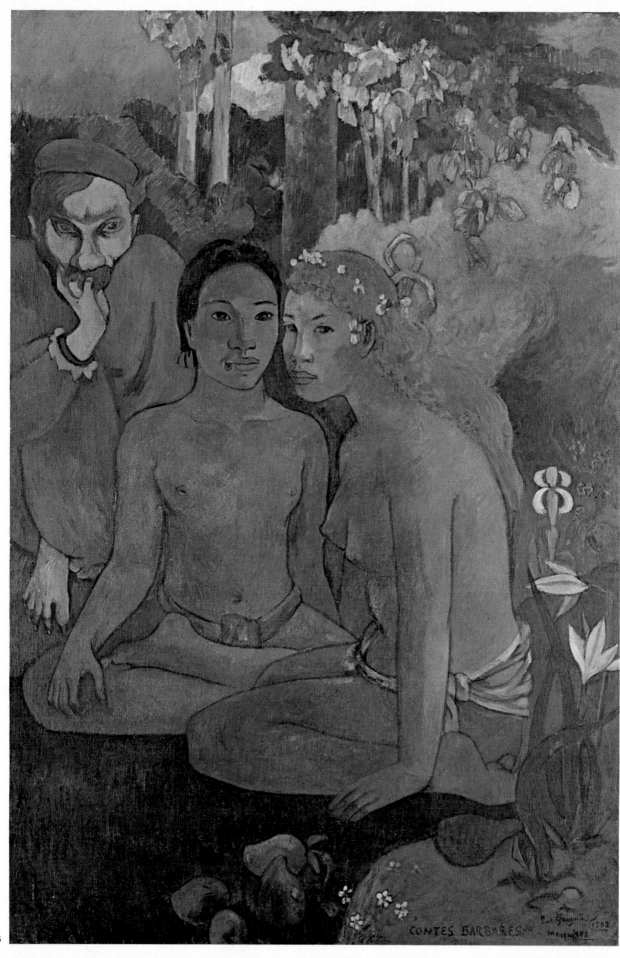

CONTES BARBARES

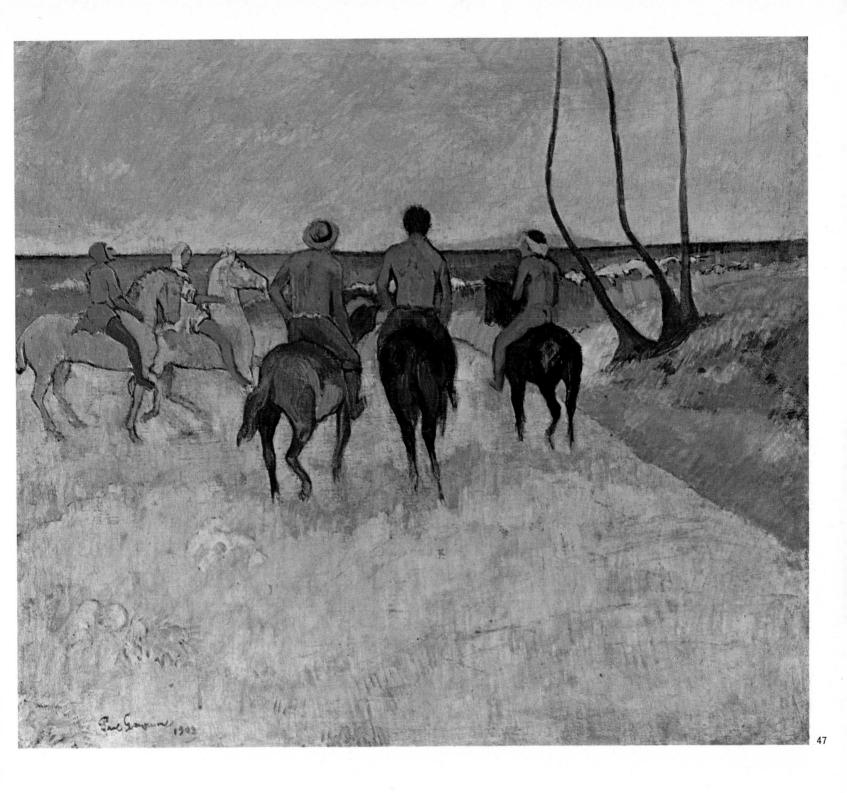

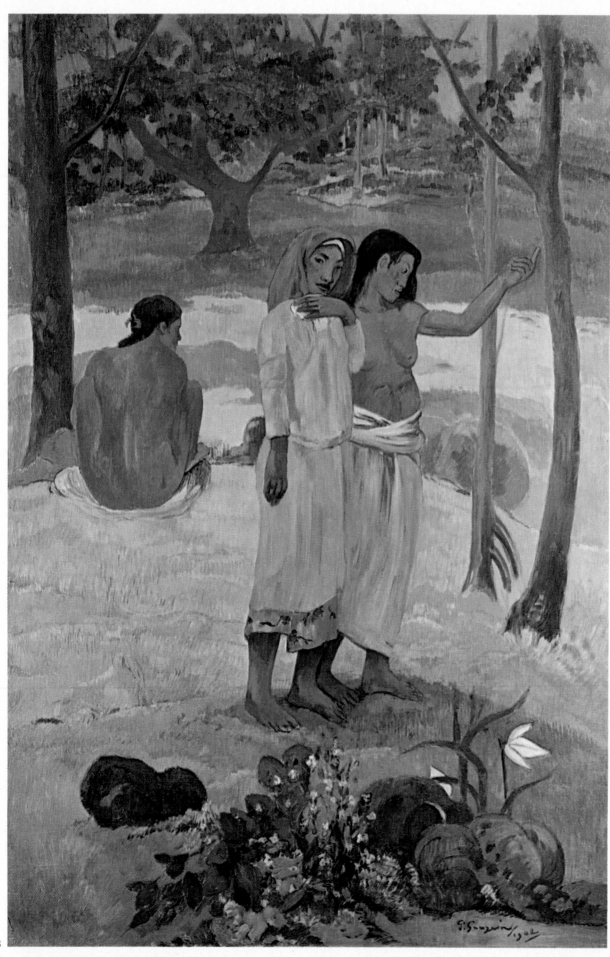